W9-BIB-513

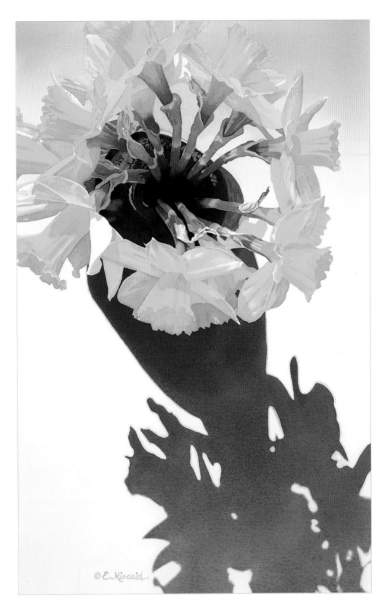

PAINT WATERCOLORS
THAT DANCE WITH
Light

ELIZABETH KINCAID

NORTH LIGHT BOOKS
CINCINNATI, OHIO
www.artistsnetwork.com

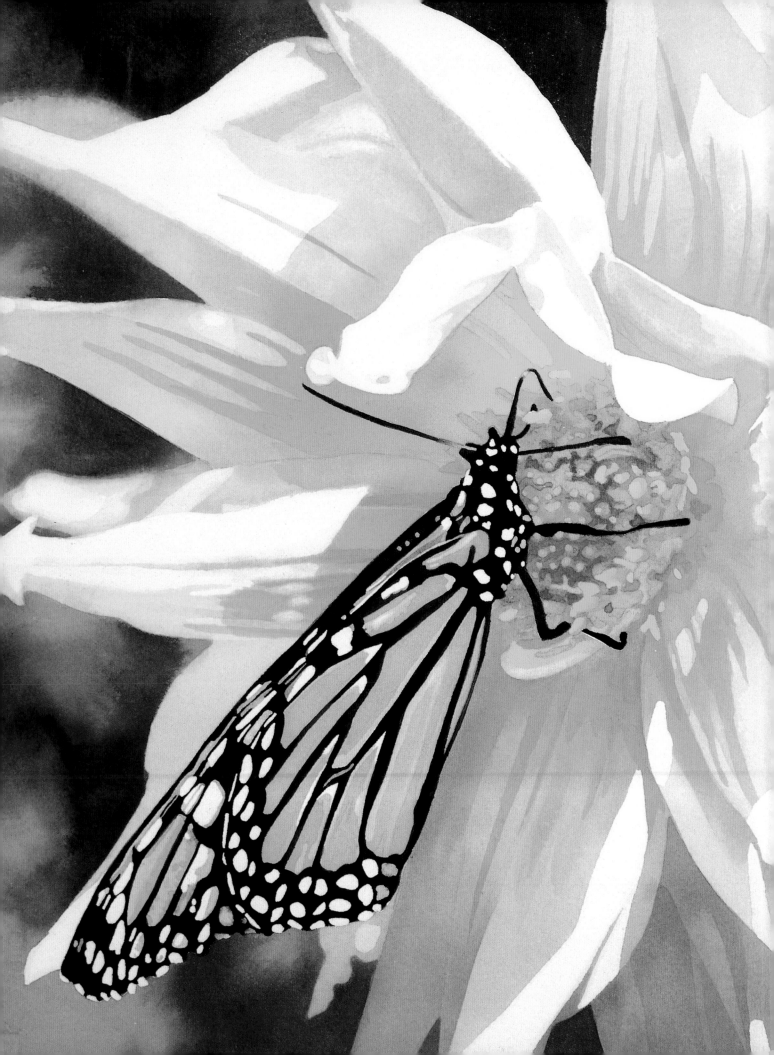

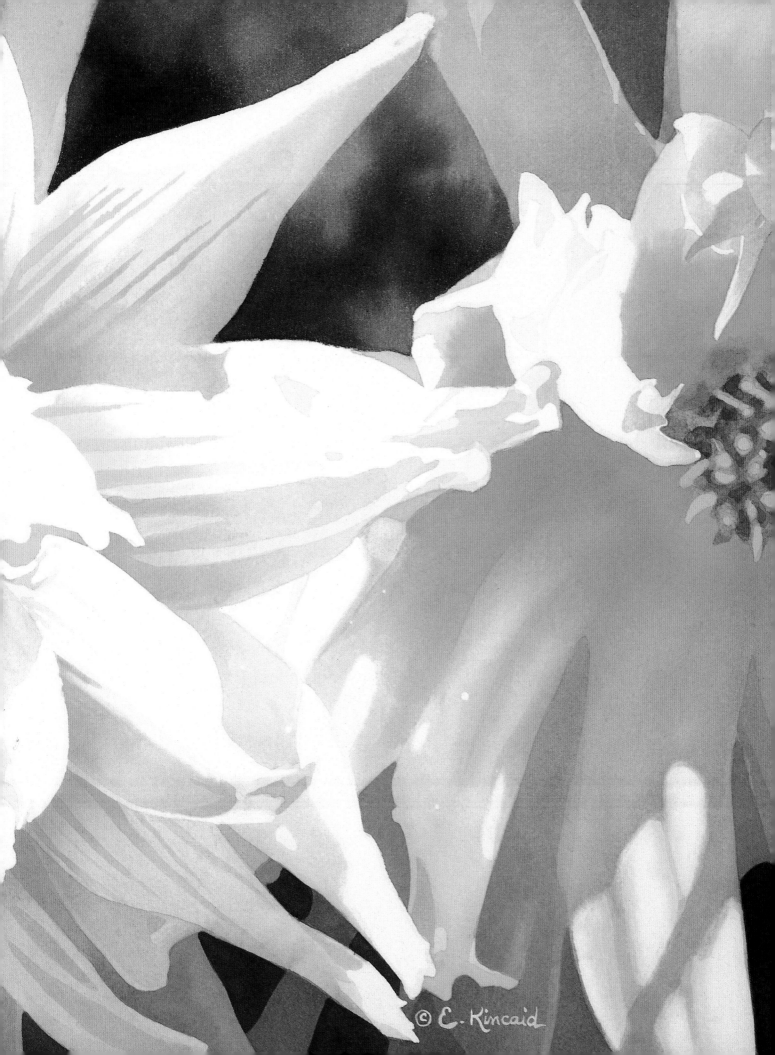

© C. Kincaid

Paint Watercolors That Dance With Light.
Copyright © 2004 by Elizabeth Kincaid.
Manufactured in China. All rights reserved.
No part of this book may be reproduced in
any form or by any electronic or mechanical
means including information storage and
retrieval systems without permission in
writing from the publisher, except by a
reviewer who may quote brief passages in a
review. Published by North Light Books, an
imprint of F+W Publications, Inc., 4700 East
Galbraith Road, Cincinnati, Ohio, 45236.
(800) 289-0963. First edition.

Other fine North Light Books are available
from your local bookstore, art supply store
or direct from the publisher.

08 07 06 05 04 5 4 3 2 1

Library of Congress Cataloging in Publica-
tion Data
Kincaid, Elizabeth.
 Paint watercolors that dance with light /
Elizabeth Kincaid.— 1st ed.
 p. cm
 Includes index.
 ISBN 1-58180-468-7 (hc. : alk. paper)
 1. Watercolor painting—Technique. I.
Title.

ND2420. K55 2004
751.42'2—dc22 2004041517

Edited by Amanda Metcalf and Vanessa Lyman
Designed by Lisa Buchanan
Production art by Amy F. Wilkin
Cover design by Julie Zelinski
Production coordinated by Mark Griffin

ART ON PAGE 1:

Daffodils in the Round
21" × 13½" (53cm × 34cm)

ART ON PAGE 2:

Butterfly Landfall
13½" × 21" (34cm × 53cm)

ABOUT THE AUTHOR

Elizabeth Kincaid grew up in Seattle, Washington, and raised a family there. Along the way, she studied painting at Cornish School of Allied Arts (now the Cornish College of the Arts), earned a BFA in graphic design from the University of Washington, and worked as a designer for a community college. She studied painting with William Cumming, Phyllis Wood, Rex Brandt, Richard Yip, and later with Leo Smith. She taught watercolor and botanical illustration in Seattle before moving to the Philadelphia, Pennsylvania, area. While living in Pennsylvania, she taught classes and workshops, became both an exhibiting member and board member of the Philadelphia Water Color Society, and showed her work in several area galleries, as well as having an annual solo show at the Museo gallery in Langley, Washington. She had a large solo show at American College in Bryn Mawr, Pennsylvania. Since moving to Soquel, California, Elizabeth has continued to show her work in galleries and also participates in the annual Santa Cruz County Open Studios show. She teaches classes and workshops in her home studio overlooking the beautiful Monterey Bay. Elizabeth's work has appeared in *Splash 6*, *Splash 7* and *Splash 8* and has won numerous awards. In 1999 and 2002, she had large solo shows at the Missouri Botanical Garden in St. Louis, Missouri. Her Web site address is www.elizabethkincaid.com.

METRIC CONVERSION CHART

To convert	to	multiply by
Inches	Centimeters	2.54
Centimeters	Inches	0.4
Feet	Centimeters	30.5
Centimeters	Feet	0.03
Yards	Meters	0.9
Meters	Yards	1.1
Sq. Inches	Sq. Centimeters	6.45
Sq. Centimeters	Sq. Inches	0.16
Sq. Feet	Sq. Meters	0.09
Sq. Meters	Sq. Feet	10.8
Sq. Yards	Sq. Meters	0.8
Sq. Meters	Sq. Yards	1.2
Pounds	Kilograms	0.45
Kilograms	Pounds	2.2
Ounces	Grams	28.6
Grams	Ounces	0.035

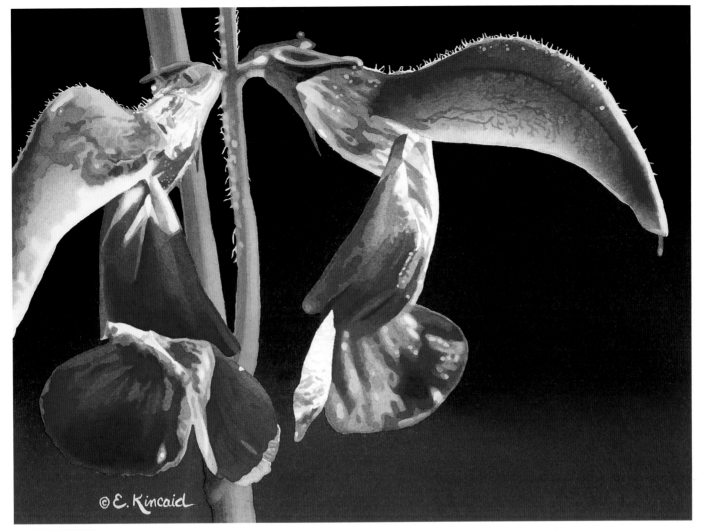

DEDICATION

I want to dedicate this book to my husband, Larry Andrews, whose love and support have made this project possible, and to all of my students, who have taught me how to teach.

Special Salvia
10½" × 14½" (27cm × 37cm)

ACKNOWLEDGMENTS

First, I want to thank acquisitions editor Rachel Wolf for the opportunity to have the great experience of making this book. I have two editors to thank for helping me put this book together: Amanda Metcalf and Vanessa Lyman. They made my job a lot easier because we were a team! This book would never have happened without the early encouragement of my Wednesday students at Whitehorse Village in Pennsylvania and the generous efforts of my friend, student and skillful copyeditor, Janet Clark. I am also grateful for the wonderful help of Robert and Mary Ann Franson, who came through for me when it was time to submit a proposal for this book idea. I don't have the words to express how grateful I am to Marv Thomas. He made possible the wonderful life I have now and he shot his globe thistle for me. I thank Sally Jorgenson for loaning me her interesting studio chair, and I give a very big thanks to my student Maggie Macro for dancing around an imaginary color wheel for my illustrations. My students have been a tremendous support and cheering section over the course of this project—their feedback on what needs to be shown to make instruction clear has been my teacher. I'm especially grateful to Cheri Joseph for letting me use her painting to illustrate a point. I'm lucky to have two dancers in my family to model for me: my daughter, Deborah Haley and granddaughter, Natasha Haley. I also want to acknowledge photographer Karen Lemon for giving permission to use her photograph of the dancer with the scarf as a reference for painting. This book was made by a whole team—the great folks at North Light and my friends and family. Paul Titangos did the large format photography of my artwork beautifully. My husband, Larry, photographed my artwork and the demonstrations and provided essential computer support so I could concentrate on the writing and painting!

TABLE OF *Contents*

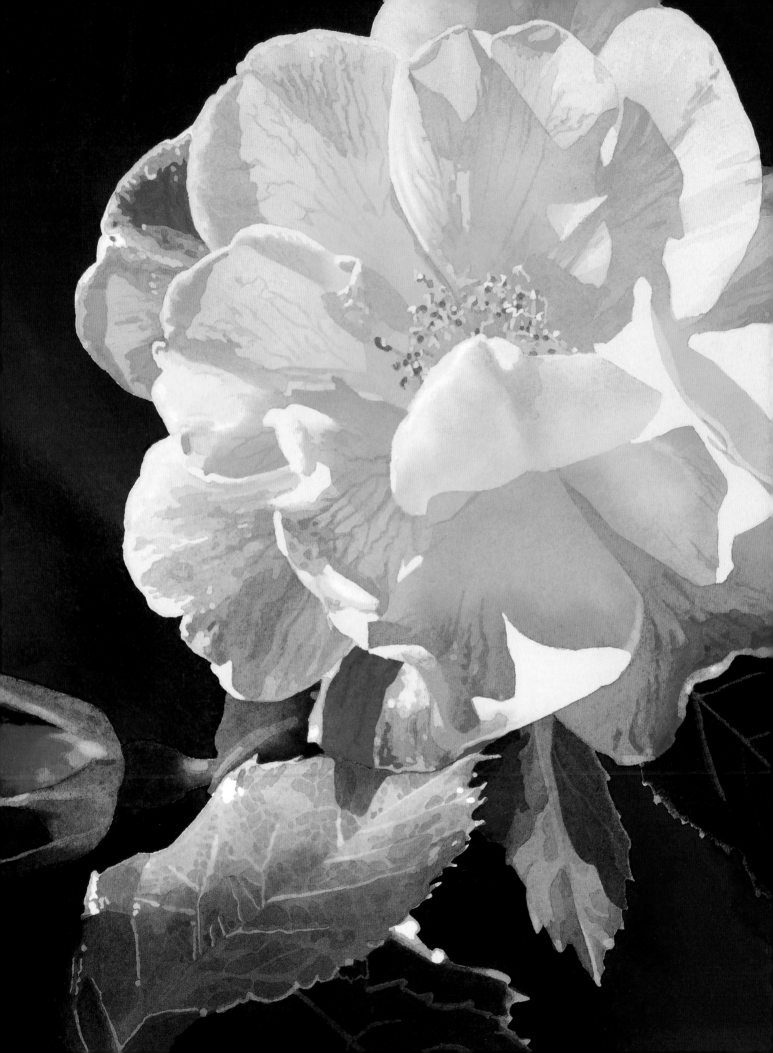

HOW I WORK, WHY I WORK:
An Introduction

My inspiration is light. Every day my muse is reborn because every day the sun rises. Light, nature and a love of the land and water have always influenced my life. Whether I was hiking in the mountains or exploring the many wild coastal ocean beaches of my childhood, nature has always been the focus of my work. As a child, I spent hours drawing horses from an imaginary world. On camping trips with my family, I drew old cedar tree stumps and rock-filled streams, sand dunes and driftwood. My family had "sunset alerts"; when there was a particularly beautiful sunset forming in the sky, we would all pile in the car to race across town to our favorite viewing spot. I still feel that same sense of awe. As an adult, I have explored many aspects of how the natural world appears, from the wildflower to the cultivated garden. My work has drawn even closer to nature over time, and now I am painting a more intimate view of life. I paint images I find in nature that attract me by their abstract shapes and patterns and the way light falls on them and brings color alive. My work has changed over the years, moving away from early academic influences toward a style that is more uniquely my own. This progression has led to less abstraction and stylization and to a more careful study of the external world. I am excited by a feeling of movement and energy in nature and colors that dance with one another. I look for subtle color shifts and then enhance those colors in my paintings so that my work has the richness of my experience of the world around me. I see the world as a bright, scintillating network of interconnecting shapes, always moving and alive. I love the complexity of nature, both the drama and the serenity. With my paintings, I seek to share with others my own sense of awe at the beautiful world in which we live. In this book, I want to teach you how to share the things that inspire awe in you.

For me, painting is an act of worship. I am an explorer, endlessly searching for new sources of joy in nature. I move in close to see the grandeur in the very small and very obscure corners of the universe. When I see a vein in a leaf or a blush of reflected color in the corner of a flower petal, I don't see unimportant detail; I see the magnificence of life. Wherever light falls, patterns are revealed, and the luminosity inherent in all living things shines forth. Color is a playground for me; I play with it, manipulate it for fun. Play with color; your paintings will come alive.

A PAINTING OF TEMPERATURE
This is a painting about heat. The hot colors of the rose contrast with the ultimate cold of Ultramarine Blue in the background—fire and ice.

Rose Gold
14½" × 10½" (37cm × 27cm)

My Process in a Nutshell

My work begins with a trip out into the natural world. With my camera and sketchbook in hand, I find and record everything that inspires me in nature. I look for strong designs and powerful effects of light as it falls on and passes through everything around me. Once a scene in nature has been isolated by my camera lens or pencil and I have studied the arrangement for its nuances, I am ready for my studio. After reviewing my slides, I choose the images with the strongest design or the most potential. I proceed to drawing on the watercolor paper once the design is worked out. I mask to protect areas of the image and then layer on many transparent glazes of pure, unmixed color. My method is not quick; it requires a real commitment of time and a great deal of patience. Its advantage is that it allows me to "feel" my way through the mysteries of a painting. Because I have time, I can ponder the consequences of any action deeply, before committing myself too much. I can avoid the need for drastic repairs, and I can catch those happy "accidents" that are the magic in any painting. Mistakes are apt to be light and easily overridden because they always come in the form of light washes.

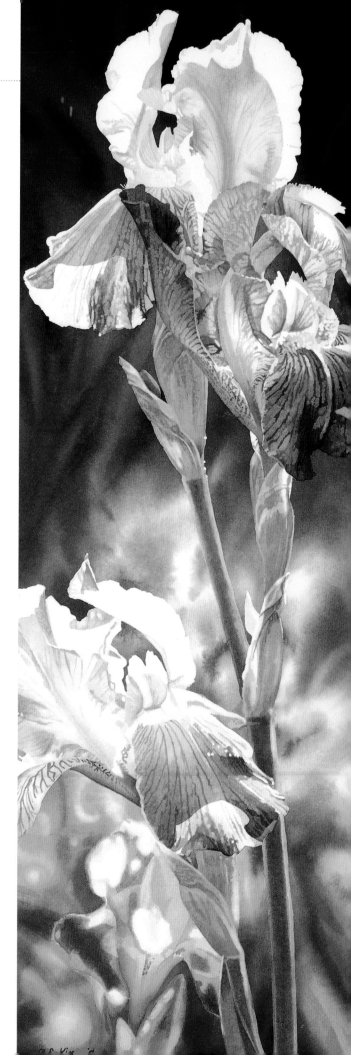

VERTICAL BEAUTY
This painting format plays with the vertical nature of the iris flower, and the background is created through direct play with the brush.

Iris Tower
29½ " × 10½" (75cm × 27cm)

Taking Calculated Risks

Many artists experience watercolor as a contact sport, complete with risk, pressure and an adrenaline rush. My method is more meditative and serene. There are moments of the excitement that come with doing wet-into-wet washes, as well as moments of being lost in a wonderful world of discovery. Layering color is an adventure—what will happen if I glaze this color over that? It is like a walk through an undiscovered wood. You're not sure where you are until suddenly you arrive. You may think that glazing will be more difficult than mixing colors, but you'll find that you gain skill as you layer, so more skillful washes cover up earlier efforts. You'll be amazed!

I take calculated risks when I paint, but I have a bag of tricks ready in case I fall. This book is that bag. Fear is the biggest enemy of anyone working in watercolor. Watercolor demands freedom but also control. Fear will come out in the way you grip your brush, the steadiness of your hand, the strength and confidence of your strokes—fear will be laid down on the paper right along with the paint. You can fly when you know that if you make a mistake a solution is *always* there. You will find your confidence in this bag of tricks. Mistakes are not tragedy; they are great blessings. As Oscar Wilde said, "Experience is the name we give our mistakes." *Every* painting, especially one you struggle with, teaches you something new about painting.

This book is about taking little steps—little steps that will become a dance.

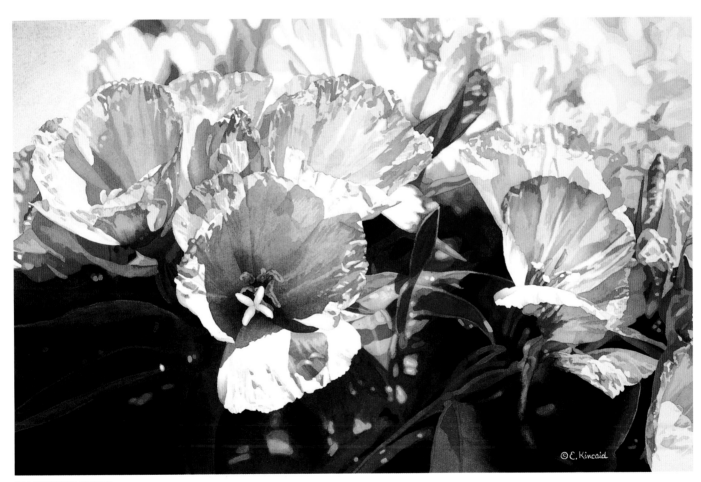

HARDY BEAUTY
These delicate appearing flowers are actually not so delicate; they can survive in very harsh, dry conditions. I love the way they seem to become light itself in the sun. This design emphasizes the way these flowers form a carpet of light on the ground.

Mexican Evening Primrose
13½" × 21" (34cm × 53cm)

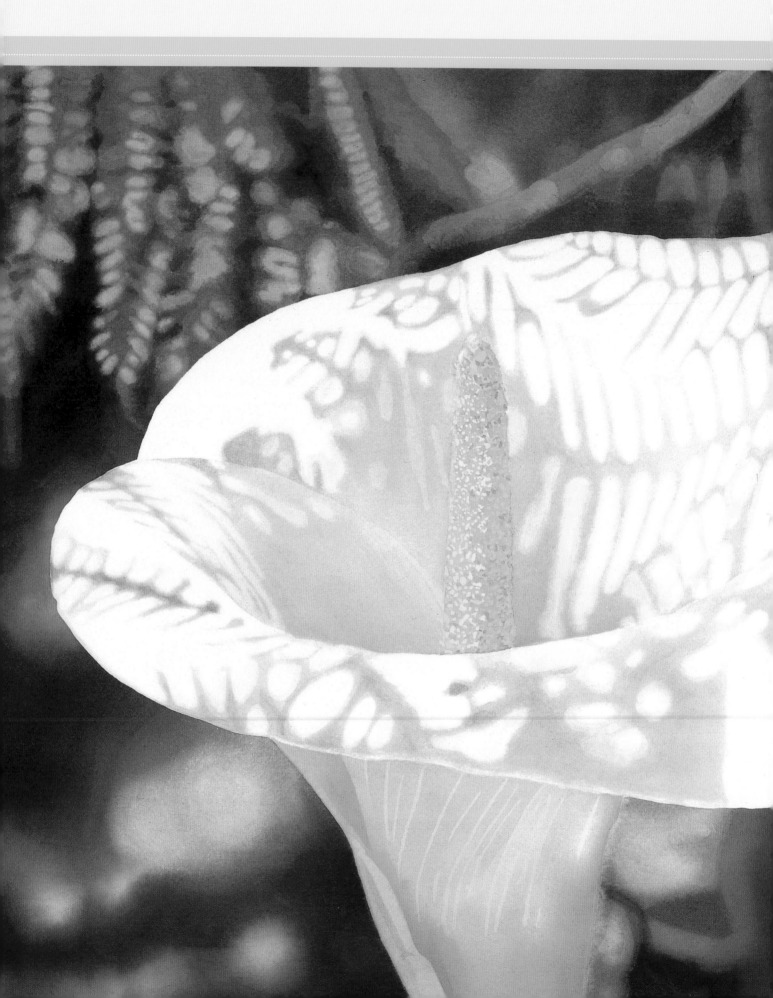

HOW TO SEE LIKE AN *Artist*

Looking at things as an artist isn't so simple. Seeing is something we tend to take for granted. After all, it's something we mastered in infancy, right?

Wrong.

Fern Shadows
21½" × 29½"
(55cm × 75cm)

@ E. Kincaid

Painting Starts With Seeing

When you're an artist, seeing isn't so simple. Most of the time, we look at things with only part of our attention. We see only what we expect to see, and every image is cloaked with labels we've been taught to attach to the world around us. In other words, you see a chair, not a conjunction of angles, parallelograms and triangles. You see a ball, not a sphere. This habit of not really paying attention keeps us from really looking at things. But to live successfully and practically, this habit is necessary.

To paint or draw successfully, however, this habit gets in the way. If you learned to draw a Christmas tree as a child, that stylized shape will intrude on your ability to really see the unique shape of an individual evergreen tree. If you drew almond-shaped eyes on faces as a child, you're apt to miss all the complexities that make up the real human eye you're trying to draw now.

HOW TO SEE A CHAIR

This curly maple chair from the 1920s can be represented with simple geometric shapes, as the diagram shows. The curving and straight rectangles that make up the chair are distorted by perspective, which causes things to appear smaller as they recede. Set up a chair of your own and study the shapes you see. Don't just label the object you see. Observe its shapes. An artist doesn't just see a chair. An artist sees the shapes and angles shown at right.

Sally's Chair
9½" × 6½" (24cm × 17cm)

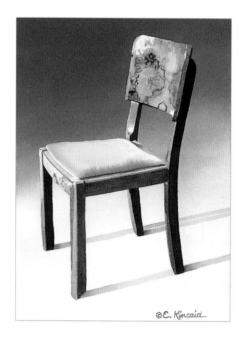

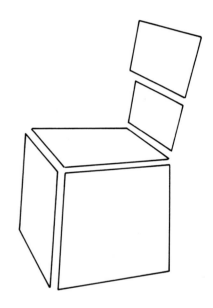

WHAT MOST PEOPLE SEE VS. WHAT AN ARTIST SEES

To process everything the senses absorb in a day, the human mind finds ways to abbreviate sights, smells and sounds into, basically, shorthand. Rather than seeing an entirely different shape every time you look at a tree, your mind just labels them all as trees and goes back to paying attention to the traffic in front of you. To paint and draw accurately, though, an artist has to shut down the shorthand part of the brain and write it all out. The average human would translate a tree to the kindergarten version of a Christmas tree. The artist needs to study the shapes and values particular to the tree he or she is drawing or painting.

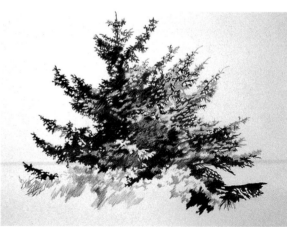

What's really there

Look at Your Subject in New Ways

The way to overcome your brain's habit of labeling objects and seeing stylized versions of them is to train yourself to see with fresh eyes that aren't jaded by years of overexposure to visual stimuli. These fresh eyes exist in the mind. It is here that we interpret the visual data taken in by our eyes. Seeing requires a total focus of your attention; it means meditating on the object before you begin the drawing.

I encourage my students to approach their work with fresh eyes. At three different points in the painting process, fresh eyes are invaluable: when creating a strong design, when making an accurate drawing and when evaluating the almost-finished painting.

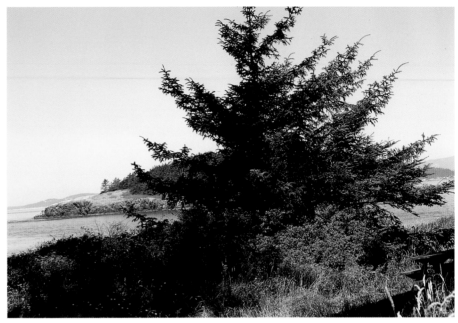

STUDY THIS TREE

Study this tree for a few minutes. Look at the shapes, values and colors and what they communicate to you. Now, to help your mind get past its desire to simply label the object as a tree and move on, try looking at it in some ways that make it look less like a tree, as shown below. This way your mind won't jump to conclusions.

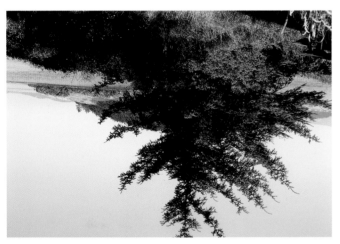

TURN IT UPSIDE DOWN

If you're working from a reference photo, turn it upside down. Now you can study value patterns, shape and the object's relation to its environment without any preconceived notion of how it should look.

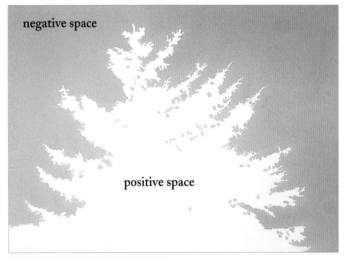

negative space

positive space

LOOK AT NEGATIVE SPACE

Try drawing and shading in the negative space, or in other words, the shape of the air that contains the object. Drawing the shape of the air to create the shape of the object also helps you break away from the label your mind puts on an object. To really fool your mind, try drawing the negative space when the picture is upside down.

Training Your Mind

Look with total focus at each scene and object you wish to draw or paint. Think only of your subject. Leave behind the thoughts about tonight's dinner and yesterday's conversation with a friend. Choosing a subject that appeals to you will help. Before you start drawing, spend some time just thinking about your subject. The following questions and suggestions can get you started:

- Look over every inch of it to get to know and understand its subtleties intimately before you begin the drawing.
- Forget that you're looking at a certain object—a rock or a vase. Just experience its color and texture. See the way light falls on it or passes through it. See the shape and color of the shadow it casts.
- Look at the way it hides elements behind it. Observe the way other objects seem to be closer than your subject. What tells you that?
- Does your object have a shiny or dull surface? How do you know?
- Is your object opaque, translucent or transparent?
- If it's transparent, what happens to the images behind it?

Forget about the drawing task for a while. Give yourself the time to take in information before rushing to produce an image.

Perceiving Abstract Form, Value, Line and Color

Ultimately, you should perceive everything you see as totally abstract forms, values, lines and color. Only when you can see in this pure way can you translate the solid, three-dimensional reality onto flat, two-dimensional paper. Understand how each interconnecting shape locks together with the others like a jigsaw puzzle and become a master of illusion.

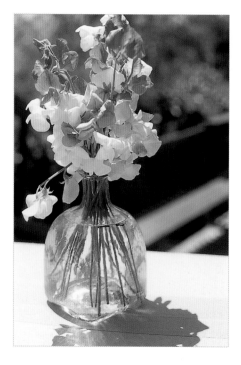

PRACTICE SUBJECT

A clear glass vase of flowers makes a good subject to practice seeing. The reflection and refraction of light through glass can be quite abstract, which helps when you're learning to trick your mind. These light effects don't fit the labels your mind makes up. Without those expectations, there's less of a barrier to seeing what's really going on. Study the scene to the left, thinking about the objects and what you're seeing. You can even go through the list of suggestions on this page. Then try it in your work.

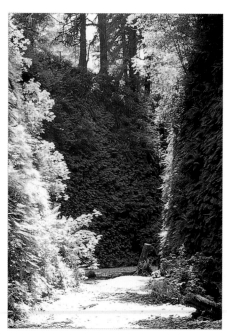
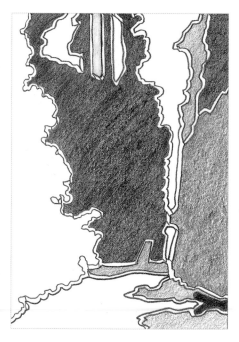

FIND THE PUZZLE PIECES

To see this scene correctly, try to see just the largest shapes clearly and then look at how they interconnect. You can identify shapes by large changes in value. In this canyon, the tall, fern-covered wall and trees in the background are much darker than the sunlit wall on the left and the canyon floor. When I look at the reference photo, I see the large shapes I've drawn at right. This sketch is similar to the sketch of shapes and angles in the chair on page 14. Seeing these shapes is the first step toward making an accurate drawing.

Lose Yourself in Your Subject

I once had the opportunity to guide a group of nonartists through an experience of true "seeing." I spent an afternoon wandering the hills in the country, surrounded by forests and fields and all the beauty of the natural world. Finally I found a small, old log. It was half buried in the ground; rotting; covered with flowering moss, lichen and stones; and bleached silver by the weather of years. I dragged it, dirt and all, back to the lodge where our group was staying and hefted it onto the podium. I set up a spotlight and covered the whole display with a drape. With my audience gathered around, I talked for a while about creativity and seeing, then I turned out all the lights in the room, uncovered the log and turned on my spotlight. While gesturing to the different details and nuances of color, texture, value and form, I guided the group in a "walk" over the "landscape" of my log.

After a while, I turned off the spotlight and asked the audience members to shut their eyes and draw the glorious, textured log on an imaginary screen. This ordinary object, something normally passed over without a second thought, became the star of my show when the audience was able to see it in a different light. Look with this same sense of wonder at the objects all around you.

MAKE YOUR SUBJECT IMPORTANT
Climb with your eyes across a complex subject as if you're so small that the subject has become your whole world. Give it that much importance in your mind.

Draw With Your Eyes

Leo Smith, a wonderful artist and teacher from Texas, used to tell a great story about one of his workshops. During a break, he took some time to rest in a sunny courtyard. One of his students happened to look out the window and was struck by the odd sight his teacher posed, just sitting, spending a long time apparently doing nothing but studying his own shoes. When Leo returned to his class and the student asked him what he had been doing, Leo explained that he was mentally drawing his shoes and that this is an essential habit for every artist to get into. Until you learn to spend a lot of time drawing the world around you without making a mark, he said, you'll be unprepared for the reality of a pencil in your hand.

Whenever Leo had the chance, he'd study things closely, moving with his eyes across the "landscape" of whatever objects happened to be around him at the moment. This practice trained his eye, just as a musician's daily practice trains his reflexes and develops his skill.

PAINT WITHOUT A BRUSH

The next time you have some time to kill, do this exercise with whatever is in front of you. You can use idle time to hone your artistic skills. Rather than becoming bored or frustrated or impatient while waiting in line, entertain yourself by "painting" whatever is in front of you. Learning to see paintings is an important first step for making skillful drawings and paintings and for recognizing and creating good design.

1. LOOK UP FROM THIS BOOK.
- *What is right in front of you?*
- *What shapes, colors and textures do you see?*
- *What shapes are being created by the light?*
- *Where is the light coming from?*

2. PRETEND THIS SCENE IS PART OF YOUR NEXT PAINTING. IMAGINE YOURSELF DOING THE LINE DRAWING.
- *What piece of the 180-degree area that you can see would you crop out to make a rectangular painting?*

- *Would you choose a horizontal or a vertical section?*
- *Study the value relationships. Would this make a good design, or would you need to change things, shifting the placement of objects or darkening something?*
- *Would you include every bit of the detail you can see?*
- *What paints would you use for the colors in this scene?*
- *Where would you start painting, and what color would you start with?*
- *What brush would you use first?*
- *How would you handle the textures?*
- *Would you wet the paper first or just plunge in with the paint?*

3. FOLLOW THE PAINTING THROUGH ALL THE STEPS TO ITS FINISH. WHAT WOULD YOU PAINT FIRST? WHAT WOULD YOU PAINT LAST?

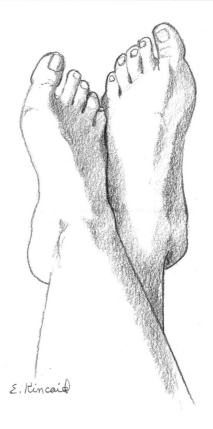

FEET ARE ALWAYS HANDY

Feet are a very convenient subject; there's usually a pair nearby (either your own or someone else's) when you need something to practice on. I sketched my feet and my husband's as he sat, curled up in an easy chair. Shoes add even another dimension. Try it yourself! Look for the shapes created by the light source: the parts of the feet that are light and the parts that are dark. It'll be a different experience each time you draw your feet.

Another Point of View

Part of seeing the world around you is choosing where to turn your head or where to place your body. You need to move. A conventional point of view for paintings is looking out and slightly down on a scene, but there are infinite possibilities when it comes to choosing a point of view.

When I'm roaming around with my camera, I think of myself as swimming through an ocean of air, able to move at will up and down and all around an object. I consider every possible angle, not just the first view I see. If I find white and yellow daffodils glowing in the spring sunshine against the dramatic backdrop of a stone wall, for example, I'd first lie down to capture the backlit flowers against the dark backdrop at eye level. Or maybe I'd look at them from underneath, set against a blue sky.

Next, I'd move around to capture the flowers lit from the side, and then maybe I'd move in close to fill the frame with a single blossom. I might even climb on top of the wall to get an aerial view or walk farther away to include a field in the foreground and an old farmhouse behind the daffodils. The image I find at the end of a long process of exploration often turns out to be the view I choose to paint in the end. Or I may develop a series of paintings this way. Take time to see every aspect of your subject.

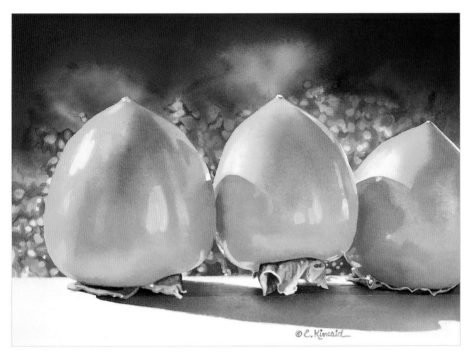

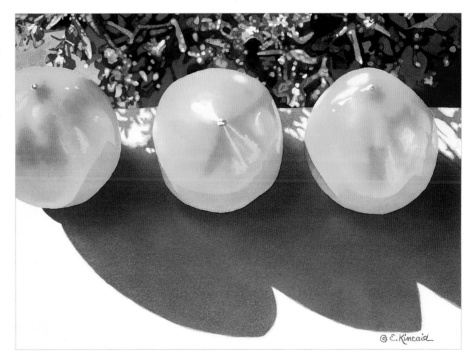

Persimmon Kisses
10½" × 14½" (27cm × 37cm)

GET MULTIPLE PERSPECTIVES

I painted the same subject using the same palette, but I painted each painting from a different viewpoint. Moving around lets me see the same objects in entirely different ways and discover new ideas and new shapes. Gather groups of objects together and then play with their arrangements. Line them up in rows. Move them around to create circles. Put them on a glass plate and see what they look like from underneath. Study how these changes affect the shapes of the shadows on the objects and the shapes of their cast shadows.

Persimmon Tops
10½" × 14½" (27cm ×37cm)

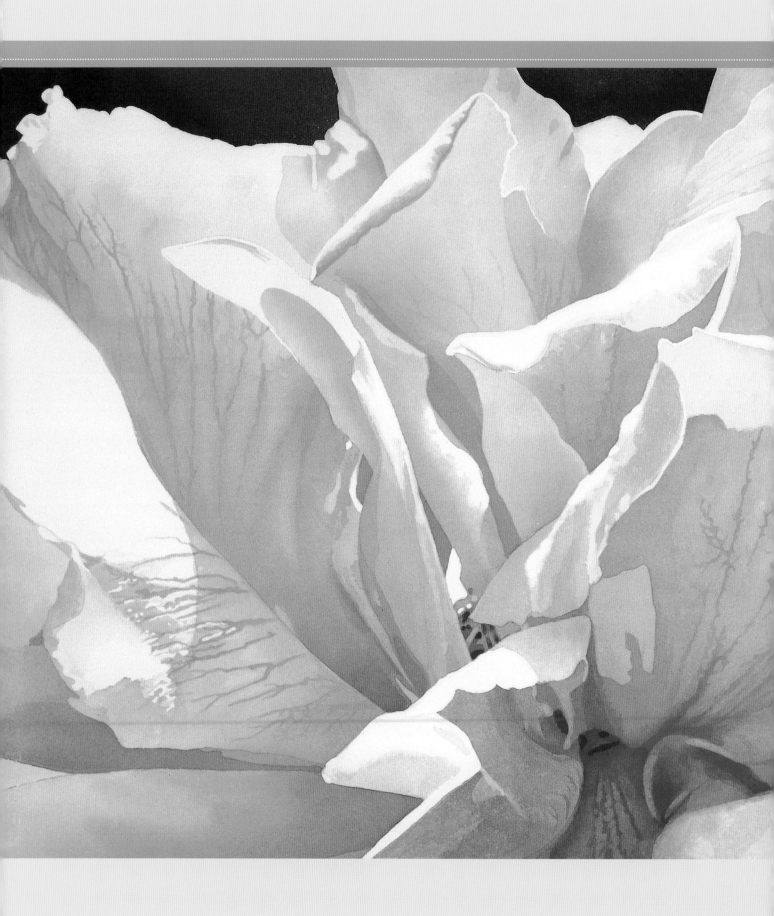

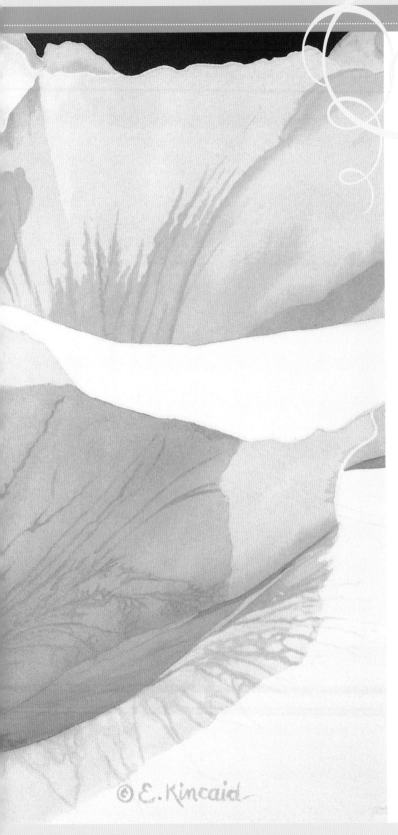

LEARNING THE STEPS:
THE METHODS
AND THE
Madness

This chapter will show you how the dance flows from moment to moment in the creation of a painting. Every step has a part to play in the whole performance, and when you master each step, you are set free to play!

Peachscape
13½" × 21"
(34cm × 53cm)

© E. Kincaid

Steps for Developing a Painting

To capture stunning scenes that make the most dramatic and powerful use of light, I follow a five-step painting process:

1. Take slides of nature.
2. Draw thumbnail sketches based on the slides.
3. Do a careful line drawing on watercolor paper based on a thumbnail that achieves good composition.
4. Apply a mask to protect some areas of the watercolor paper from paint.
5. Layer many transparent glazes.

Painting on Location vs. in the Studio

Working on location, directly from nature provides a valuable experience, but I find I do more powerful work in the studio, where I can take time to consider the design. On location, time creates constant pressure as the the sun moves overhead, altering the entire scene moment to moment. I often wish I could stop time so I could capture the light. Working on location also tempts me to paint the world just the way it is instead of changing elements to make the painting stronger.

Because I do my best work in my studio, I make sure it's as close to ideal as I can make it. My studio used to be a master bedroom. I paint in a corner that has windows facing east, south and west. It sits high, so I can see the ocean and lots of sky. It feels like I'm working in a tree house! I use a lot of movable furniture so the space stays flexible. A well-arranged work space helps make your painting flow.

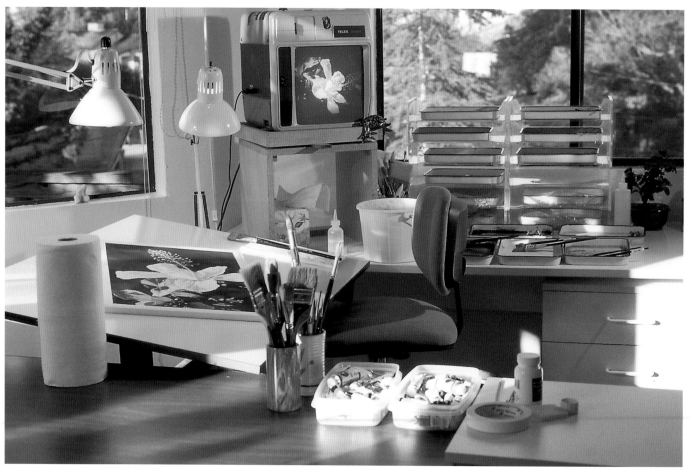

WELCOME TO MY WORKSTATION!

A U-shaped workstation is most efficient for me. I have a table on each side and an adjustable drafting table at the bottom of the U. With a rolling chair, this puts as many work surfaces within reach as possible. I prefer a drafting table to an easel because I can easily twirl a painting around to work from any angle. My slide viewer sits at eye level. I store my many palettes in stackable office paper trays.

I like lots of light, so in addition to my three windows, I have three lamps, each using full-spectrum incandescent bulbs, with one hanging directly over the painting. I rounded out my setup with a collection of tables and taborets and bookshelves for my reference books and slides. By choosing a smaller room for my bedroom, I freed up the master bedroom for a studio and its large closet for storage.

Set Up a Well-Equipped Work Space

Here are the tools I use in my studio:

Brushes
- ¹/₄-inch (6mm) flat scrubber brush (fabric painting stencil brush, similar to a very small bristle brush; good for lifting paint and softening edges)
- 1-inch (25mm) kolinsky sable flat
- 1 ¹/₂-inch (38mm) flat wash, natural/synthetic blend
- 2-inch (51mm) flat wash, natural/synthetic blend
- no. 0 through no. 16 kolinsky sable rounds
- no. 3 through no. 16 sable/synthetic blend rounds
- old, small brush (for applying masking fluid)
- toothbrush

Drawing and Painting Surfaces
- Arches 300-lb. (640gsm) cold-pressed watercolor paper
- Saral graphite transfer paper

- sketchbook for thumbnails
- tracing paper

Drawing Tools
- kneaded eraser
- no. 2 pencil
- no. 2B pencil
- no. 2H pencil
- retractable white eraser

Paints
I use tube paint from the following manufacturers: Winsor & Newton, Daniel Smith, Rembrandt, Holbein, and Grumbacher. (See page 80 for specific colors.)

Palettes
I use a separate 10 ¹/₂" × 7 ¹/₂" (27cm × 19cm) enamel palette for each color. For colors I use less often, I use small plastic or china palettes.

Masking Materials
- clear ammonia (to thin masking fluid)

- Frisket Film, matte surface
- permanent waterproof fine-tip marker
- rubber cement pickup tool
- ruling pen
- Winsor & Newton colorless liquid mask or Grafix Incredible White Mask

Other Materials
- craft knife
- drafting tape (to tape down drawings and masking film)
- 1-gallon (3.8l) water container
- Gator board (for mounting the paper)
- kosher salt
- natural sponge
- paper towels and tissues
- scissors
- slide projector, rear projection
- small squeeze bottle with water
- white artist's tape (for mounting watercolor paper to board)

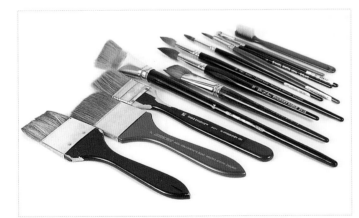

MY FAVORITE BRUSHES
From left to right, the brushes are Daniel Smith 2-inch (51mm) flat wash; Winsor & Newton 2-inch (51mm) flat wash; Grumbacher 1 ¹/₂-inch (38mm) flat; Manet kolinsky sable no. 24 flat; Cheap Joe's Art Stuff CJAS 1-inch (25mm) flat; Daniel Smith no. 16 round kolinsky sable; Winsor & Newton no. 10 round kolinsky sable; Winsor & Newton no. 8 round kolinsky sable; Winsor & Newton no. 8 Sceptre Gold; Daniel Smith no. 4 round; Winsor & Newton no. 1 kolinsky sable; Grumbacher ¹/₄-inch (6mm) flat scrubber; toothbrush.

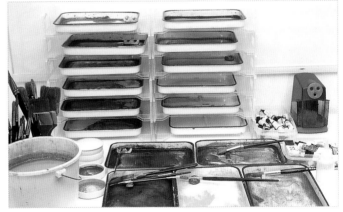

FIND A RHYTHM
Before I start painting, I put a brush in each color's palette and add water so I don't disrupt the flow of my painting process by washing a brush every time I switch colors. I fall into a rhythm as I paint: reach for a brush, add water to the paint, stir, touch the brush's tip to a pad of paper towels, apply paint, return the brush to its palette, remove excess water and color from the painting with a tissue or thirsty brush, and let the paper dry as I plan and prepare for my next step. If I want to add another color to the glaze before it dries, I'll have the color mixed with water and ready to go so I can just drop the first brush and pick up the next one without skipping a beat. I set everything up so the actual process of applying paint to paper happens efficiently. This way, I can make the most of the time before the paper begins to dry.

Designing Photographs

I use photography for more than just recording images. I also use it as part of my design process. I like to work in my studio, so my reference photos need to be good quality. I use my camera as a cropping device while I'm out gathering reference material.

I start by scanning an area, just looking around to see whether anything attracts my eye. I search for scenes in which light creates something magical from something ordinary. When something catches my eye, I look at the scene through the viewfinder to crop out a rectangle, a slice of reality.

Thinking about design at this point is critical. Cropping and composing in the photography stage doesn't have to be the final word on what you'll paint, but it's a wonderful first step. I may choose to paint the scene just as I photographed it. I may crop the image on the slide to get a closer look or to concentrate on just a portion. Or I may decide to move some objects around, add elements or eliminate them during the thumbnail stage. No matter what direction I take, the better the composition I start with, the better the painting will be.

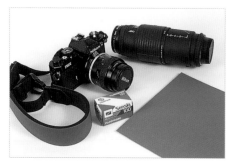

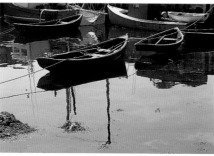

MY PHOTOGRAPHY SUPPLIES

I use a Nikon FM2 camera, which is a manual camera, because it gives me control over lighting and focus. I use a Nikon 55mm macro lens, but I also carry a Sigma 75-300mm zoom lens for close-ups or expansive views. Lately, I crop in tighter and tighter to get closer to the subject. This intimacy has immediacy and impact, making my paintings more powerful. I use a gray card to insure my exposures are correct (18 percent gray cards are sold in most photography stores).

CHOOSING THE BEST COMPOSITION

After finding the best composition I can in a photograph, I'll decide whether to use the photo as is or crop in. From there, I'll make whatever adjustments I can to improve the composition. I discovered this wonderful arrangement of boats at Fox Point in Nova Scotia, on a painting trip with a group of artist friends. I used my zoom lens to get shots at a couple of distances. Back in my studio, I decided that I liked the more close-up photo on the right. I decided to crop in on the scene a bit more to get a tighter design and focus on what was important to me.

SLIDES CAPTURE LIGHT

Slide film is a necessary part of my supplies. Slide film has a wider range than normal print film, so it captures more nuance and subtlety. On prints, shadows can go black, highlights can go white or pink, and colors can be overly simplified. If a subject has a whole range of reds, a print will show them all as one. Slides aren't perfect either, but they come a little closer to the way our eyes see things. Color play and light effects are important facets of my artwork, so I want to make sure I capture as accurate a view as possible.

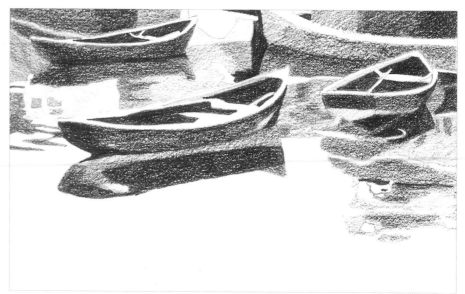

IMPROVE UPON GOOD DESIGN

You can make any changes during your thumbnail sketch. For instance, I removed some shadows from the foreground and then extended the shadow on the right to balance the composition vertically. The better your composition when you start the thumbnail sketch, though, the better it will be when you improve it.

Designing Thumbnail Sketches

Back in my studio, I'll ponder a slide for a day or two before moving on to the next step, the thumbnail sketch. A thumbnail sketch is a small, abstract design that uses black, white and just a few grays to find the value pattern. Basically, a thumbnail should translate the colors of nature into their relative values. Just indicate the masses and the major shapes of light and dark without trying to render a detailed image.

Next, evaluate this simplified version of the scene. Does the composition work?

How can you change it to make it better? Look for clarity and strength of a pattern first. Look for dynamic movement, patterns and lines formed by masses of objects that will lead the eye. When the goal is to make impact with light, you have to master value.

VALUE PATTERNS

A painting needs to work in patterns of value, color, texture and line. When you're lost in all the other elements, it's easy to forget about value, which is what really gives a painting impact. If every other quality of a painting is sound, a strong value pattern can mean the difference between merely being accepted into a show and winning a prize. Strong value design is the rhythm in a song, and color and shapes are the notes. Without value contrast to make it coherent, a painting will seem chaotic, maybe insipid, and it will lose impact.

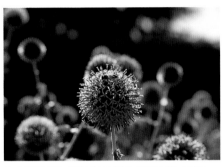

DON'T BE AFRAID TO GET CLOSE
Both of these shots of a globe thistle interested me, but the close view intrigued me the most because of the way the light made the bees glow. What I didn't like was the lollipop shape, so I explored several ways to crop the image.

CONCENTRATE ON VALUES
I chose this cropping of the close-up photo above, using a square format and including only a quarter of the flower. Even though the glow of the yellow bees is what attracted me to this composition, I concentrated only on the value pattern of the scene for this thumbnail. The lighting may make a composition interesting, but the value pattern has to make it work.

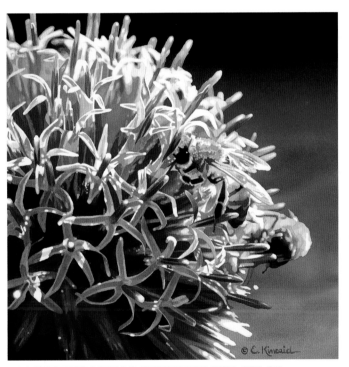

PAY ATTENTION TO BOTH VALUE AND COLOR
I used my reference photo as a color guide and my thumbnail as a value guide. Notice the subtle value changes within the purple that really make this painting work.

Gift from Marv
13½" × 13½" (34cm × 34cm)

Line Drawing

Once you're satisfied with a design, it's time to put a line drawing on watercolor paper. Keep your line drawing as light as possible so it's less likely to show through when the painting is finished.

Draw not only the outlines of the objects but also the outlines of all shapes of light, shadow and local color within an object. For instance, draw the shapes of pink spots on a white flower petal, the shape of a shadow on a wall, or the stripes on a shirt. Draw large-scale shapes within textures, such as the grain of a piece of wood and veins in leaves and flower petals; draw any details you may want. You might choose not to paint some of these details, but the information will be there if you need it.

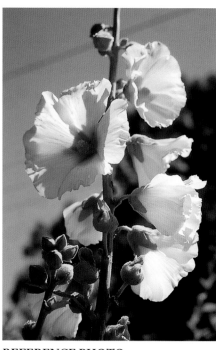

REFERENCE PHOTO
Study your reference photo closely. Think about all of the elements and shapes you want to include in your painting. Look for changes not just in shape but also in value, color, texture, and look for anything else you want to communicate.

The Right Pencil for Watercolor Paper

Use a no. 2 pencil, which is medium soft. If you use a lead that is too hard, you might create ditches as you press down. These ditches will fill with paint and dry as dark lines. If your lead is too soft, you might smudge the line, which will gray the paper and make your painting less luminous.

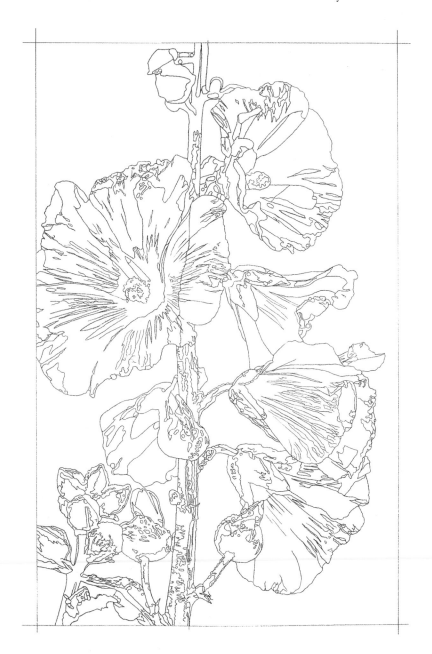

LINE DRAWING
On your line drawing, indicate all the details you want to show in your painting. Use a line to indicate the edge where a color shifts or changes. Indicate the outside forms of objects, and mark changes within the objects, such as a transition from shadow to light on a petal. Notice all the detail in this line drawing for White Tower *(final painting on page 30).*

Combining Reference Photos

If you use multiple reference photos, make sure you combine the elements so they're compatible and work well together. For example, you should make sure the light is coming from the same direction in each photo.

These pygmy goats, who live near me, are some of my favorite subjects, especially the babies. I used my zoom lens to get close. The best time to shoot them is in the early morning because the sun, which is close to the horizon at that time of day, casts long, interesting shadows.

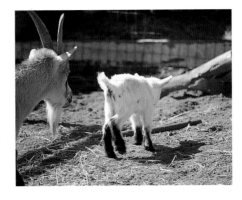 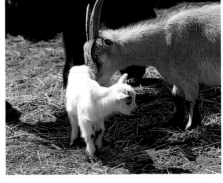

PERSPECTIVE IN COMBINED IMAGES

Make sure the elements are proportional; the laws of perspective state that the goats on the right should be smaller because they are farther away. If you move a piece of the drawing toward or away from the viewer, you'll also have to change the size either by redrawing it or changing the size with a photocopier. But you always can move elements from side to side unchanged without violating laws of perspective.

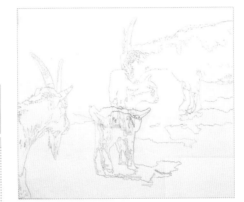

COMBINE LINE DRAWINGS
On tracing paper, I drew separate drawings based on each photograph. I moved them around to find the best design, positioning them so they overlapped. When I found a combined image that I liked, I taped the drawings together.

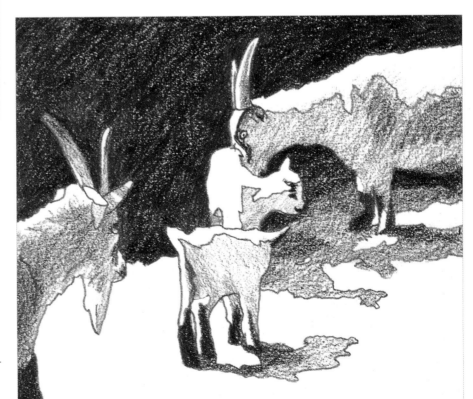

REEVALUATE THE DESIGN
Using the combined line drawings and photographs as references, I drew a thumbnail of the new design. This allowed me to check the strength of the arrangement. The thumbnail also allowed me to integrate the two shadow patterns, simplifying them and pulling them together. Light is an essential part of painting, and you have to get the shadows right to get the lighting right.

Transferring a Line Drawing

If your composition has changed a lot from the photograph, especially if you have combine elements from several photos, work out the changes and finalize the drawing on tracing paper first. Then you can trace or transfer the drawing to a clean, undisturbed piece of watercolor paper. You can transfer simple images with tracing paper. For more complex images use the more expensive transfer paper.

TRANSFERRING WITH TRACING PAPER, STAGE 1
Start with a line drawing on a clean piece of tracing paper. Turn the paper over and scribble heavily on the back of the line drawing with a no. 2 pencil. This leaves a heavy band of graphite on the tracing paper under the original drawing.

TRANSFERRING WITH TRACING PAPER, STAGE 2
Flip the tracing paper back over and attach it to your watercolor paper with drafting tape. Use a hard, sharp 2H pencil to redraw the drawing, following all of your original lines exactly. The pressure of the hard pencil will transfer the graphite from the back of the tracing paper to the watercolor paper. Make sure all the lines have been clearly transferred before you remove the tracing paper.

THE RIGHT KIND OF TRANSFER PAPER

Using transfer paper is more expensive but much quicker than transferring with tracing paper. I use Saral Graphite Transfer, which comes in a roll, like wax paper. It comes in several colors, but I use the graphite version because it can be erased easily. Don't use carbon paper or transfer paper with a waxy surface, which will leave permanent marks on your watercolor paper. Graphite paper is reusable, so save it for your next line drawing.

TRANSFERRING WITH TRANSFER PAPER
Start with a line drawing on a clean piece of tracing paper. Tape the tracing paper over your watercolor paper with a sheet of graphite transfer paper, graphite side down, between them. Go over the lines of the original line drawing with a 2H pencil to transfer graphite from the transfer paper to your watercolor paper. Be careful not to rest your hand heavily on the paper as you work, because the transfer paper can leave smudges. If your lines are too dark or there are a few smudges, lift the excess graphite gently with a kneaded eraser.

Building Color

Washes of pure, unmixed colors will develop luminosity and brightness in your paintings. The pure white of your watercolor paper also plays an important part. The brightest possible white is the white of your paper, and that brightness in turn makes the other colors seem bright in comparison.

The first step before applying any paint is to decide which areas you need to protect with masking. (Chapter Four talks about masking techniques in more detail.) After masking the areas you want to preserve, begin thinking and forming strategies. Painting with layers of color is a lot like playing chess: You need to think a lot before moving, but actually making your move takes just a moment.

Strategy is everything: Know which color to use next, which brush you'll need, which technique to try. Decide all this ahead of time because once your brushes are loaded and the paper is wet, it's time to move fast, fast, fast. Make quick and even strokes with a light touch, and then stop painting. Just sit back and watch the action.

Mixing With the Eye

I build up the colors in my paintings using many transparent glazes or washes. I don't mix colors on my palette; I use my palettes only to stir my paint with water and to make sure the paints form even pools and have no lumps. (Lumps of paint act like chunks of crayon; the brush will drag the lumps across the paper, leaving lines.)

When mixing your paint with water, keep in mind that uneven pools of paint on the palette translate to uneven washes on the paper. Fixing an uneven wash requires more brushstrokes, which isn't ideal. In watercolor painting, it's important to use the fewest number of strokes possible, partly to avoid stirring up earlier layers of paint. Also, the longer you work, the likelier it is that the area will begin to dry, producing an uneven wash.

When I mix two different colors together in a painting, I do it optically on the paper rather than manually on the palette. This means I paint one color on the paper, let it dry thoroughly, and then apply the next transparent color. Light passes through the top colors, then the bottom colors, and finally bounces off the reflective white paper. It travels back through those layers to the viewer's eye. The colors appear to be mixed together even though they're separate layers.

For instance, to get a green, I'd first paint a strong wash of yellow and then float a very weak wash of blue on top of it. Different pigments have different covering power. If the color I want contains a yellow, I'll make sure to start with it first because yellow has the capacity to glow through any layers above it. In this case, the resulting green has a more luminous quality than a green mixed on the palette, because light passes through separate layers of paint, catching the qualities of both.

MIX COLORS EVENLY

Make sure each of your colors is mixed well before you start painting. Look for lumps in your palette or hiding in your brush. Lumps of pigment haven't mixed with as much water as the rest of your mixture, and the pressure of your brush will draw lines like a crayon. Once a strong line like this appears, it's difficult to remove.

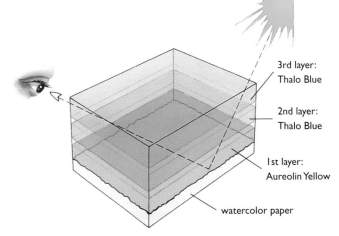

3rd layer: Thalo Blue

2nd layer: Thalo Blue

1st layer: Aureolin Yellow

watercolor paper

LAYERS ARE MORE LUMINOUS THAN MIXTURES

Think of transparent layers of paint as layers of gelatin. If you're careful to let the first layer thoroughly dry and then gently pour the second layer, each layer remains separate, though they work together well. Notice how the light passes through these glazes and the eye sees them as mixed.

Consider the Needs of Each Painting

If all you have is a hammer, everything looks like a nail. Don't treat your paintings as if the only tool you have is a hammer. One approach to painting doesn't fit all situations. Many artists use large washes of color to pull a painting together, to unify it. Some follow the rule that you should always begin with large brushes and use small brushes only at the end.

I often work that way, thinking large and free in the beginning and concentrating on details later, but I don't paint the same way for each painting. Sometimes I find that beginning with the details works better. If I paint details first and then lay a glaze over them, the hard edges of the details blur slightly. This approach pulls all the elements together more strongly. For

instance, the rocks in a stone wall create detail and texture, but you want the plane of the wall to read as a whole, without individual rocks jumping out. Finishing with an overall glaze instead of the details will pull it together.

UNIFYING A PAINTING

Laying larger washes over details softens the details and integrates them into the painting. Also, by painting the details first, you won't have to strain to see the original line drawing through layers of paint. The details can always be enhanced in the final stages, if needed.

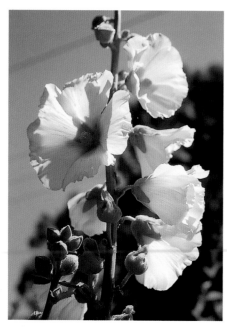

REFERENCE PHOTO
To paint these flowers, I wanted to show the stunning details of the hollyhock, which most people rarely get close enough to see. But I didn't want the details to compete with the beauty of the flower as a whole or with its composition. So I painted the details first and layered glazes over them to integrate the details into the whole.

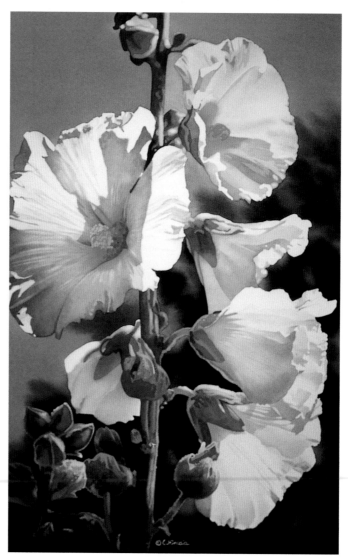

FINAL PAINTING
Notice how much of this painting uses the white of the watercolor paper, which I protected by masking.

White Tower
21" × 13½" (53cm × 34cm)

Layering Glazes

Below are two stages of the painting *White Tower*. Study the progression between the two to understand how glazes work together. If you like, paint an abstract image just to experiment with layering and to see how the colors in each layer interact and mix. Simply apply some masking fluid randomly and then apply randomly overlapping layers of paint.

In *White Tower*, I masked the petals, stems and buds first, then I painted the background quickly and evenly with large brushes and a lot of freedom. When I had painted the initial large washes, I removed the masking from the entire area and used masking fluid to protect the small areas I wanted white or a different (usually lighter) color then the areas around them. Always protect larger areas with masking film. In the progression below, the masking fluid appears brown.

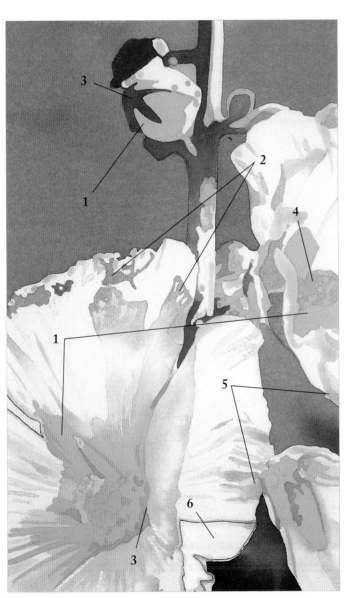

PAINTING THE DETAILS, STAGE 1

I began glazing this flower by painting the details first. This way, the larger washes that followed had a chance to dominate. The goal is to create detail that softly merges within the larger shapes. The last wash in any stack of washes will soften the edges of the detail shapes and dominate the layers underneath. Here, the small shapes of Aureolin Yellow, Ultramarine Blue and Thalo Blue are still jumpy.

1. First glaze: Aureolin Yellow 2. First glaze: Ultramarine Blue 3. Second glaze: Thalo Blue 4. Second glaze: Indian Yellow 5. Masking fluid 6. Masking film

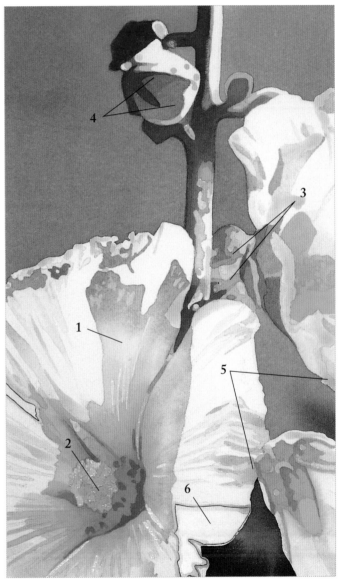

ADDING LARGER WASHES, STAGE 2

Here, the larger glazes of Indian Yellow and Thalo Blue begin to tie together all the separate pieces. You begin to see flower and bud instead of spots of color. Now is the time to switch to the larger brushes since you're painting larger shapes. The yellow and blue glazes become blue shadows on the white flower and green bud.

1. Second glaze: Thalo Blue 2. Second glaze: Indian Yellow 3. Third glaze: Thalo Blue 4. Third & fourth glazes: Thalo Blue 5. Masking fluid 6. Masking film

Which Brush Should You Use?

The first step in using a brush is to choose the right brush for the job. When in doubt, choose a larger brush because it holds more paint.

Generally, artists use flat brushes to cover large areas with washes and use round brushes for details. Of course, both types are very versatile. Round brushes that are big enough can be used to lay down a wash, and flat brushes can make interesting shapes that can liven up your painting. Choose the brush you want, and then use all of it. Don't be timid!

Hold the brush lightly, and make sure you have enough ease of motion to create varied strokes with a turn of your wrist. Although there is no one right way to hold a brush, I prefer to hold it at the top of the metal ferrule or higher.

Become familiar with the nature of your brush and your own body mechanics. The hairs on these brushes are carefully aligned with the handle so they'll respond to what your hand tells the handle to do. Your shoulder, elbow and wrist are hinges that allow your hand to move

easily in a smooth arc. Use your whole arm when you paint to take advantage of these qualities, and use the whole brush to take advantage of the full length of the hairs.

The most valuable advice I can give you is to practice. With practice, you'll gain confidence, and with confidence, you'll become as agile with your brush as with your hand. The brush needs to become an extension of your hand, arm and thoughts.

FLAT BRUSHES

Flat brushes can cover a large area with just a few strokes, and fewer strokes mean a smoother wash. You also can use flat brushes in an expressive and lively way. They can make strokes in a large range of widths. Notice how the shape of the line changes depending on whether the brush is held horizontally or vertically. The wider rectangles and parallelograms work well for buildings.

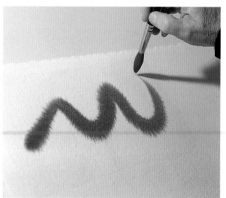

ROUND BRUSHES CAN PAINT THICK OR THIN

Use only a slight pressure on a round brush to paint a thin line. Use a lot of pressure to paint a thick line. Notice the difference in how the bristles lie on the paper.

COMBINATION OF CONTROL AND FREEDOM OF MOVEMENT

Round brushes can draw flowing or straight lines. They're great for laying down organic shapes and expressive washes. Round brushes allow more control than flat brushes for detail, yet rounds still have the bounce you need for free strokes.

Position of the Brush

Holding the brush at different angles to the paper creates an infinite variety of effects. Pointing the handle of the brush in the same direction as your stroke creates a smooth line. Holding the brush at a right angle to the stroke you're painting will create a rougher stroke because you're limiting your mobility and because the brush hairs are more vulnerable to jamming against the rough paper and making a jagged line.

Holding the brush at a different angle to the paper also affects how the paint lies on the paper.

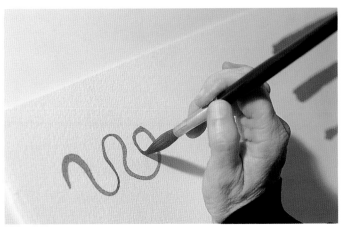

VERTICAL

Hold the brush vertically with a light touch. Angle your wrist up so you're not holding the brush too close to the hairs. Cup your hand as if you're holding an egg in your palm and grasp the brush between your thumb and your other fingers. It may seem awkward at first, but once you get used to it, this position will give you a lot of flexibility, control and versatility. Use this grip to sign your paintings, when you want to change the direction of your stroke without stopping and whenever you need to paint with delicacy.

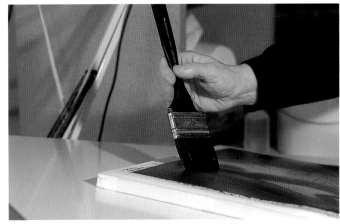

LESS THAN VERTICAL

Hold the brush between your thumb and fingers. Lean the brush toward the direction you want to travel, then pull in that direction. Holding the brush slightly less than vertical lets you control pressure as well as shape. For the first wash, load the brush with a lot of paint and press firmly to get good coverage.

For subsequent layers, apply a thin glaze by skimming the brush lightly across the surface. Don't bear down or scrub. Use long, overlapping strokes to get a smooth wash or glaze.

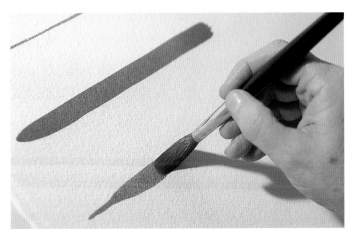

45 DEGREES

Holding the brush at a 45-degree angle from the paper allows a continuous motion between thick and thin strokes. Remember to hold the brush in a light grip with your fingers. Don't grasp it with your palm. With pressure, the entire length of the hairs of the brush touch the paper, making a thick line. This angle allows you to switch between the two stroke widths in the same motion.

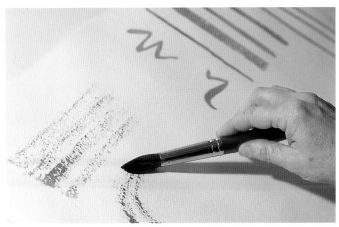

NEARLY HORIZONTAL

Holding the brush practically horizontal to the paper is a great way to create texture. This technique works best with cold-pressed or rough paper, which has more texture. The pattern it creates is slightly random—great for light sparkling on water, tree bark or rocks. With a light load of paint on the brush, skim the brush sideways across the paper so the brush only makes contact with the "mountain peaks" and not the "valleys" of the cold-pressed or rough paper.

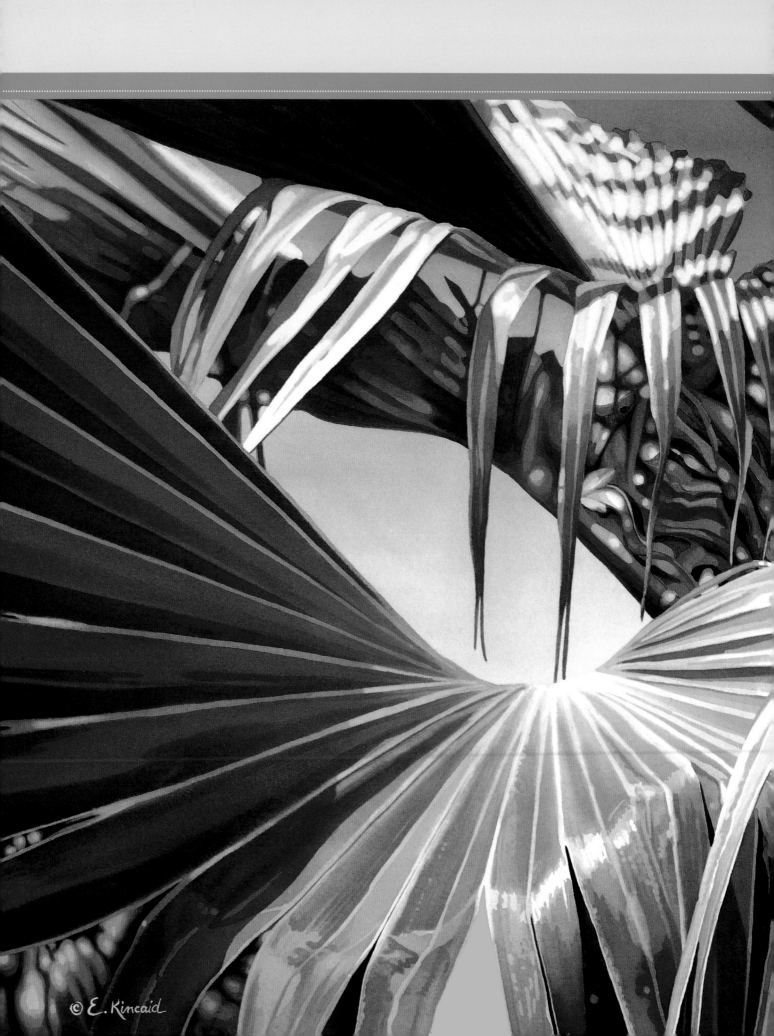

© E. Kincaid

COMPOSITION:
CHOREOGRAPHY FOR THE *Eye*

Strong paintings have strong designs. Use a simple structure to hold all of the elements of an image so your painting will have a stronger impact. Begin every painting with a close look at design, and end every painting by checking to make sure the design is strong.

Palm
22" × 29 ½"
(56cm × 75cm)

The Goal of a Successful Painting

My goal is to entrance someone with my painting, but first I want to entrance myself. I want the viewer to visually dance through the painting, get lost in it and thoroughly enjoy the experience of moving through it. Imagine your painting hanging on a wall with other artwork in a show. Someone walks by, stops at your work, and looks and looks and looks. Then the viewer moves closer to inspect it, moves on, returns, and stops to look at your painting again. To capture that much interest is a worthy goal.

Capture your viewers' interest by rewarding them for looking at every inch of your painting—for looking at all of it. Create a path of focus that pulls the viewers along, gradually delivering them to a center of interest where they stop then move on, only to return again and again, like a line of dancers weaving around a room.

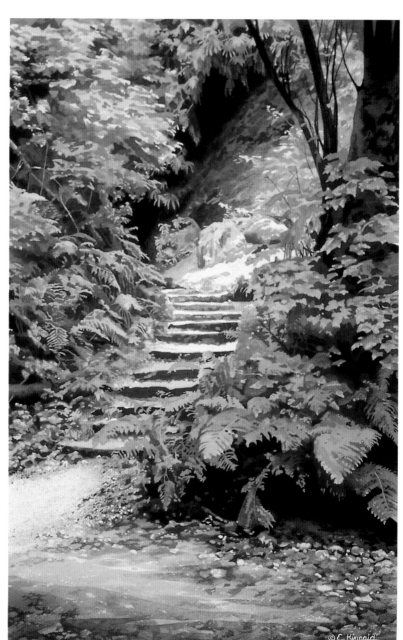

THE LITERAL PATH

By beginning the design process for Fern Canyon Steps *with a thumbnail value study, I made a map for where I want the viewer's eye to go. The range of values and contrast allow me to orchestrate the movement in a painting. In the thumbnail, most of the surface is some value of gray or black. This shift toward darker values gives any white areas more power to attract the eye because the white is rare. I strengthened the attraction by setting black next to the white, creating a high contrast area. By manipulating the placement of contrasting values, I lead the viewer's eye from the lower right to the left and then diagonally toward the upper right. The the top of the stairs, where the value of the sunlight contrasts with that of the deep forest beyond, becomes the focal point.*

Fern Canyon Steps
21" × 13½" (53cm × 34cm)

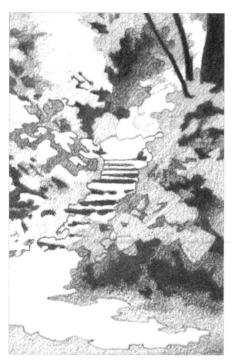

THUMBNAIL

Guide the Viewer Through Your Painting

Because design is so important in capturing viewers' interest, artists have come up with rules to make this process simpler. Some of the more common rules include (1) never placing the focal point of a painting in the exact center or on the edge of the rectangle, (2) always varying the sizes of major components (3) never leading the eye off the image by running strong diagonals into a corner, and (4) never placing a person facing the edge of the paper.

You often make design decisions like this intuitively—you just find yourself preferring one arrangement over another. The time to consciously apply design principles is when you evaluate your initial idea. This is why making a thumbnail sketch is so important; it allows you to step back from the idea *before* you've committed yourself. If the value relationships in an image threaten to weaken the painting's impact, make changes. In watercolor, the best time to change the design is before you do the drawing on the watercolor paper.

Rules are only guides; they are not sacrosanct. Understanding the reasons the rules exist is far more important than following the rules. If a rule doesn't work for you, simply address its reason. You can successfully break any rule if you solve the problem that rule addresses.

There are many ways to deal with problems in design. By introducing strong visual elements elsewhere in a painting, you can redirect the eye. To avoid drawing the eye to a problematic area, you can reduce the color or value contrast in that section.

Apply the design principles of strong and varied value contrast, of varied shapes and varied sizes, and of a path for the eye when you develop your thumbnail. Before you begin painting, decide on a limited palette of colors that will give your painting harmony and cohesiveness. Pare away everything that distracts from the single most important story in the painting. While you work, make choices that strengthen the design and make your focal point more compelling. At the end, check your painting for design flaws that may have crept in while your attention was elsewhere, but don't forget to check with your intuitive eye, too! Do you *like* the painting?

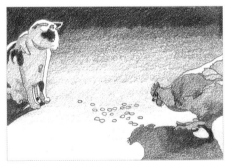

USE VALUE TO LINK MAIN ELEMENTS

In this thumbnail for Cat Watch, *the gradation of value from black at the top to white at the bottom links the cat and the chicken, creating a cohesive image. The choice of background values also sets up the play of light against dark (the cat) and dark against light (the chicken). When you play with these value relationships, you create a more dynamic image.*

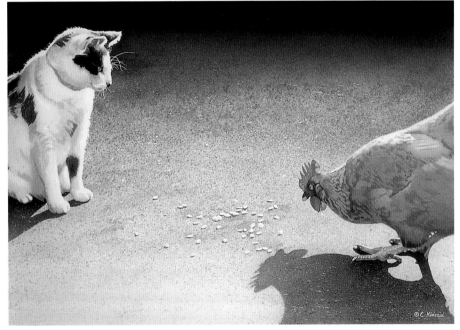

USE VISUAL TENSION TO LINK ELEMENTS IN A PAINTING

Both the cat and the chicken are on the extreme edges of the painting, and you could consider either one to be the focal point. What holds them together is the tension that exists in the space between. This "empty" space has only seeds, but they are attracting the chicken. Cats and chickens are natural adversaries. This painting asks, "Who is in charge here? What is going to happen?"

Cat Watch
13½" × 21" (34cm × 53cm)

Creating a Path of Focus

A path of focus is like a path through a forest. If you want an animal to follow that path, you must place treats all along the way. Each painting contains a similar path with visual jewels placed along the way, leading the eye from one to another, weaving around the picture plane.

Think about this traditional compositional device; the center of interest. Typically, the center of interest has some pathway sweeping directly to it from the perimeter of the paper. How long is that path? Probably not much longer than the radius of the page.

The strength of the center of interest may be enough to draw a viewer to it, but how long will the viewer stay at that center of interest (and at your painting) if you have provided only a short path without any other bits of interest along the way?

There are many rules of composition, but breaking them is sometimes the fastest route to a really dynamic painting. Trying to stick to all the rules can lead to stiffness and repetition, and it can stifle the imagination. Never placing the center of interest in the center of a composition is the rule that probably carries the most weight, but even central placement has been done successfully.

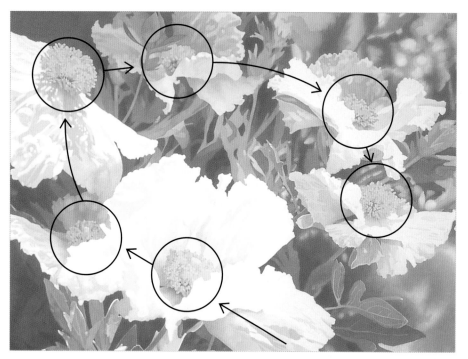

LEAD THE EYE ON A VISUAL DANCE
The eye follows the path marked by the bright centers of these Matilija poppies. The eye is attracted to what is most rare in any painting. In this case, dark greens, blues and violets dominate the painting, so the hot spots—the yellow centers and white petals—stand out.

Ladies Dance
22" × 29½" (56cm × 75cm)

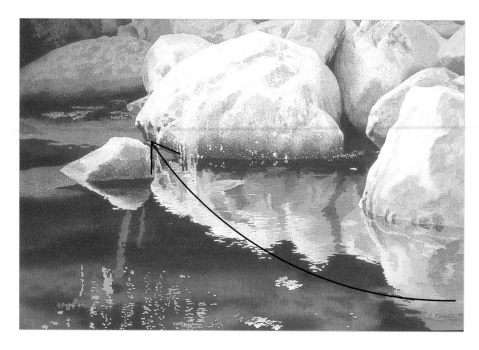

FOLLOWING A DIRECT PATH
The simple underlying structure of this painting of a cove in Nova Scotia leads the eye right to the group of rocks. Complex textures and reflections in the water give the viewer more to contemplate.

Rocks at Aspetogan
14½" × 22" (37cm × 56cm)

Underlying Structure: The Key to Design

The key to design and composition is to search for some underlying structure, some large, abstract form or line upon which the entire painting can be built, such as a large S or cross shape. Different artists are attracted to different kinds of structures and shapes. They will paint them over and over, even when painting entirely different subjects. For instance, they may be inspired to paint horizontal or vertical bands, and they may paint flat landscapes, still-life subjects on tabletops, or interiors. Diagonals, round shapes and curving S-shaped lines attract me, so I love to paint rocks, hilly land, seascapes, flowers and arrangements of elements that snake back and forth, leading the eye to the center of interest. Lately I have been drawn more and more toward painting patterns, which cover the paper without any one center of interest. Take another look at images you love. Do you see recurring shapes?

THE CROSS FORMAT

The crack in the rock wall of this quarry and its reflection provide for the vertical axis of this cross design. The junction of the crack with the waterline creates a focal point for the eye. Placing that focal point to the left of the center of the painting gives that side more visual weight. Allowing one section of the painting to dominate energizes the composition, like music with a strong beat.

Afternoon With Leo
22" × 29½" (56cm × 75cm)

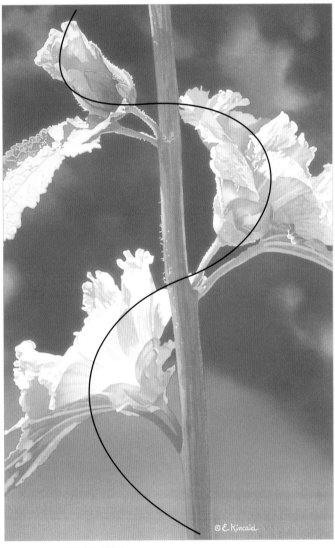

THE CURVING PATH

The strong vertical line running down the center dominates this painting, but the flowers on either side create movement by leading the eye back and forth through the rectangle.

Mallow in the Pharmacy Garden
21" × 13½" (53cm × 34cm)

Strengthen Your Design

These substructures can be helpful guides when you design a painting. They are commonly used to aid with design decisions.

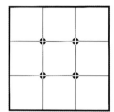

FIGURE A

CREATE NINE EQUAL SQUARES

When using Figure A, place the center of interest at one intersection and any secondary centers of interest at other intersections. Where the grid lines run off the edges of the rectangle is a good place to have major lines exit the painting; this avoids dividing the painting into equal halves. Try this with your next painting. Instead of placing elements randomly, ask yourself, "What drew me to this scene?" Place that element at one of these intersections.

Sugar?
10½" × 14½" (27cm × 37cm)

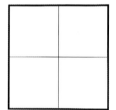

FIGURE B

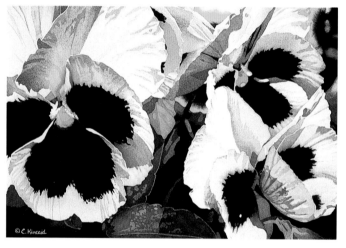

CREATE FOUR EQUAL SQUARES

When using Figure B, place the center of interest in one of the quadrants. All the quadrants should have something of interest, but this doesn't mean they should be treated equally. In fact, some should have more weight than others. Three quadrants might contain all the details in a painting, but the fourth could provide interest through graded washes or soft-edged calligraphic strokes. Most of the contrast and interest in Pansies at Home falls in the bottom and right-side quadrants, while the upper left is relatively quiet but not totally empty.

Pansies at Home
11" × 14½" (28cm × 37cm)

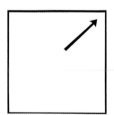

FIGURE C

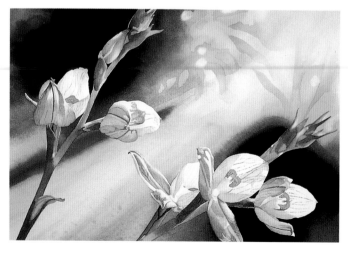

ONE RISKY FORMAT

Avoid a strong line running diagonally off the paper in any corner, as shown in Figure C, because this leads the viewer's eye out of the painting. If you want to direct a diagonal line into a corner, include elements that will pull the eye back in. First Orchid has a strong diagonal band of light splitting the painting in half, but its soft edges flare out at either end, giving the eye a path back into the painting.

First Orchid
10½" × 14½" (27cm × 37cm)

Subdividing the Rectangle à la Mondrian

Subdividing a rectangle is another way to think about design. Piet Mondrian, a Dutch painter from the early part of the twentieth century, used horizontal and vertical black bands to create unequal-size boxes filled with white or primary colors. Mondrian directed the viewer's eye within the world he created. Mondrian's composition forces the viewer to look at certain spots in painting. Those spots attract the viewer because of their intensity relative to the surrounding field of white and black. When you decide where to place major elements in a painting, you subdivide the rectangle just as Mondrian did. The only difference between Mondrian's style and a representational painter's style is you can recognize the subject matter in a representational painting.

If all the shapes within your rectangle have the same form and size, there will be a very static quality to your painting. It will lack life. For this reason, vary your shapes and the spaces between them.

Each color has a visual weight. The greater the intensity and impact of a color, the greater its weight. Think of a bar balanced on a center support with sliding weights on either side. If one weight is heavier than the other, it needs to be closer to the center point than the lighter one in order to create an equilibrium. Also, the size of a colored shape will increase or decrease its weight. Red is relatively more intense compared to blue and yellow, so it has greater weight. Blue can be intense, depending on its value and on which blue you choose.

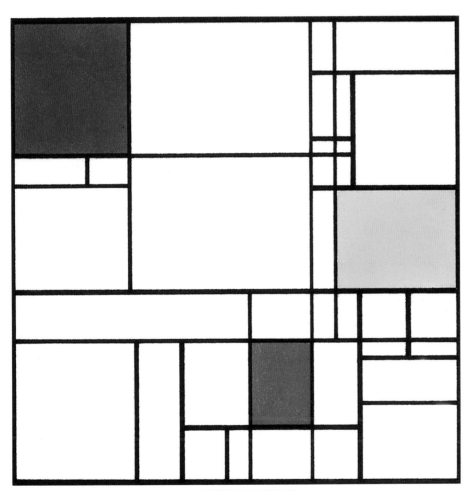

DIRECTING THE EYE THROUGH THE PAINTING
I created this Mondrian-like design using watercolors. Many of Mondrian's paintings have just a few lines and are much simpler than this painting. They are successful because of how the space is divided and how the colors are placed to direct the eye through the painting.

PAINT LIKE MONDRIAN

Try to create a Mondrian-like painting. The first step is to divide your rectangle into a series of rectangles that are different in size and proportion. Do this by drawing a sequence of vertical and horizontal lines that divide the space unequally. Once you are pleased with the division you have created, choose three shapes to fill with the primary colors: red, yellow and blue. The challenge here is to create balance despite the unequal color weights and rectangle sizes.

The Importance of Contrast and Movement

Contrast can be a matter of color, such as using colors at their most intense or placing complementary colors next to one another. Contrast can also be a matter of value, such as black and white next to each other or two colors with very little difference in value side by side. In representational painting, contrast is an important tool to create the illusion of real space. Low-contrast areas tend to recede, while high-contrast areas advance.

Movement can be created by line, whether formed by the edges of shapes or created directly with calligraphic strokes. Movement can be rapid, with straight lines and sharp angles, or slow, with soft, flowing lines and gradual transitions.

Imbalance also creates movement. You can't take a step to move forward, unless you first place yourself in imbalance. A static, perfectly balanced painting is like a dancer standing perfectly still. In that stillness, there is no possibility of movement. At the other extreme, a total lack of balance in a painting will glue the eye to where the center of interest or greatest weight is, preventing travel throughout the entire painting. The painting will seem to tip in that direction. Seek a compromise between balance and imbalance.

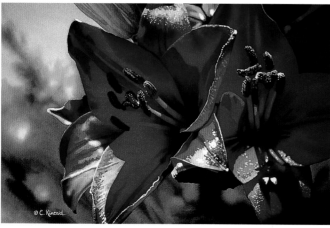

COLOR AS CONTRAST

In Lilies in Red, *contrast exists because of the juxtaposition of intense red and green. These complementary colors really stand out against one another.*

Lilies in Red
13½" × 21" (34cm × 53cm)

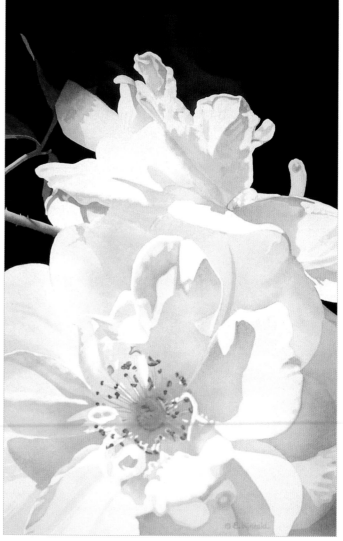

VALUE AS CONTRAST

Here the delicate subtleties within the white roses are contrasted with the dramatic red-black of the background.

Two White Roses
21" × 13½" (53cm × 34cm)

Creating Balance Without Stagnation

Design is a matter of finding balance in nature and creating it in your work. For instance, strong design has to have a dynamic quality, but this does not necessarily mean it has to be high energy or frenetic. Your painting can be very peaceful as long as it has some sense of movement, something that draws the eye into the painting.

As mentioned earlier, one rule prohibits placing something important in the center of the painting. Center placement is static and nondynamic; it doesn't move the eye. However, there can be other forces at work in a painting that offset the static quality of a symmetrical composition.

Consider a painting that has elements with high contrast on only one side and the center of interest in the middle. This arrangement creates an off-balance dynamic tension that is an antidote to the anchor at the center. Another way to activate a static composition is to place strong diagonal lines that draw the viewer's eye into and back out of the center. Diagonal lines or elements placed along the diagonal lines can create the sense of movement that is necessary for dynamic flow in a painting. The goal is to be in balance but not static.

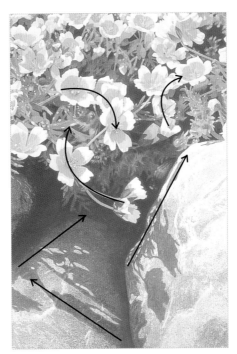

DYNAMIC DIAGONALS
The crevice between the two rocks divides this painting down the center. The diagonal lines formed by the clusters of flowers and branches pull the eye away from the center, providing movement.

In My Mother's Garden
22" × 14½" (56cm × 37cm)

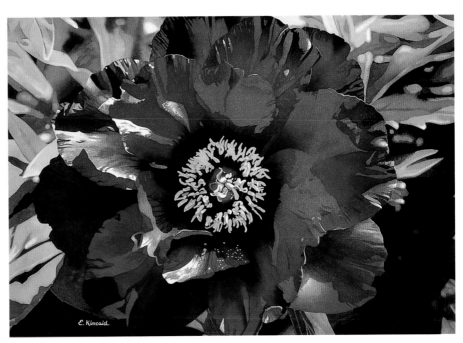

THROWN OFF BALANCE
In Well Centered, *the peony forms a bull's-eye image at the center of the rectangle. Throwing off the rigid symmetry of this design is like placing a larger child at one end of a seesaw—his end weighs more, unbalancing the the system. I reduced the value contrast in the lower right of this painting; the deep red petals and the dark background link together visually and ultimately create one large shape. By using similar values in this corner, I gave the right side of the painting more weight.*

Well Centered
13½" × 21" (34cm × 53cm)

Ruling the Rules

A successful painting is worth a thousand rules. You can break a rule successfully by introducing other forces that create a sense of movement and dynamic flow around a center of interest in your painting.

Artists are often warned not to place the center of interest on the edge of a painting. If a painting's focal point is too close to the edge of the paper, it can lead the eye off the edge. If you focus attention on the edge of a painting, you need to do something elsewhere in the painting to pull the eye back into it. You must balance the focal point at the edge with another element. You don't have to use a rigid, exact kind of symmetry; you could choose a dynamic, informal symmetry.

On the other hand, choosing to place the center of interest on the edge, while risky, can also lead to dramatic impact. Having high contrast or visual excitement crash against a barrier increases the tension and interest of a painting, rather like watching a dancer do pirouettes right at the edge of the stage.

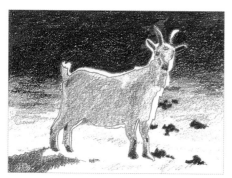

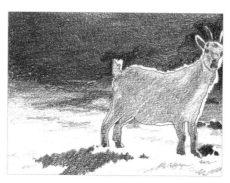

EXPLORE YOUR OPTIONS
When designing a painting, use thumbnail sketches to try different options to see what the results might be. When the goat is in the center, the composition has less impact and becomes static. Placing the goat's head at the edge of the composition creates a lot of tension—the image feels uncomfortable because the goat's face is so close to the edge. It also creates a strong diagonal through the composition.

COMPENSATE WHEN BREAKING RULES

Don't get hung up on a list of rules; you might create rigid paintings that are clones of what other people have done. Your work will lose the originality that following your own vision gives you. It's important to have a sense of the rules but not to feel locked into them. You can break every rule ever made—the most dynamic, powerful paintings frequently break some rules. These paintings are gutsier. You have to understand a rule to break it and be successful. Remember, compensate when you break a rule.

ADJUSTING THE THUMBNAIL
Pulling the goat's head slightly back from the edge gives the eye some breathing room to circle back around through the painting, yet this placement in the upper corner gives the painting dramatic impact.

One Goat Looking
10½" × 14½" (27cm × 37cm)

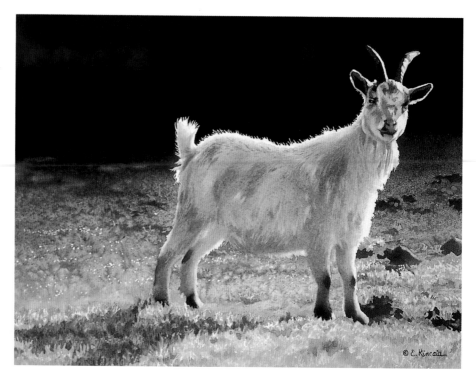

Testing Your Composition

One way to evaluate the impact of your composition is to turn it upside-down. This should be an important part of your working process. Sometimes at the thumbnail stage, you have a question about your concept or how your composition is working visually. Turn the thumbnail sketch and reference photograph upside down and evaluate them from this perspective. It is also a good idea to frequently turn your painting upside down while painting. Be sure to stand far enough away so that you can easily evaluate it. Facing a painting towards a mirror is another way of getting a fresh view. Look at the design, but don't label the objects in it; just see shapes.

These practices allow you to evaluate the design as an abstract, to see it with fresh eyes. Abstract the world in your mind and then re-create those patterns of shapes and colors on the paper. You may be a realistic painter using a great deal of detail. This does not mean that you can afford to ignore the abstract qualities of your image.

If you remember the goal of painting—capturing the viewer's attention and holding it—the decisions about whether to follow particular rules will sort themselves out. Don't allow the rules to rule you. Painting is like juggling—there are many balls in the air at once. Therefore, sorting out questions of design before you begin to draw and paint is important. Explore and determine your composition using thumbnail sketches before beginning your painting, not after you have already committed yourself to a mistake with many layers of paint. Design first, then refine your design throughout the creation of your painting.

SELECTING THE RIGHT IMAGE
I loved the lilting quality of these hibiscus as they reached up into the light. I liked the white band running through the image between the sky and the dark foliage. By turning the slide upside down, I saw that the pyramid of distant foliage at the center of the background distracted my attention from what was most important to me, and it anchored the design too strongly because of its placement in the center of the composition.

CORRECTED COMPOSITION
I loved the image, but it wasn't working compositionally the way it was cropped in the photograph. I created thumbnail sketches to try out some ideas. I raised the whole composition up so there was less sky, extended the shapes at the bottom to create a wider band and eliminated the distracting background image.

MASQUERADE: PROTECTING PURE COLOR AND *Light*

I like to work freely and quickly with large brushes as often as I can. Using masking materials allows me to take advantage of the spontaneity of a fluid medium such as watercolor and to respond to my own impulses.

Spotted
11" × 14½"
(28cm × 37cm)

© E. Kincaid

Using Masking Fluid

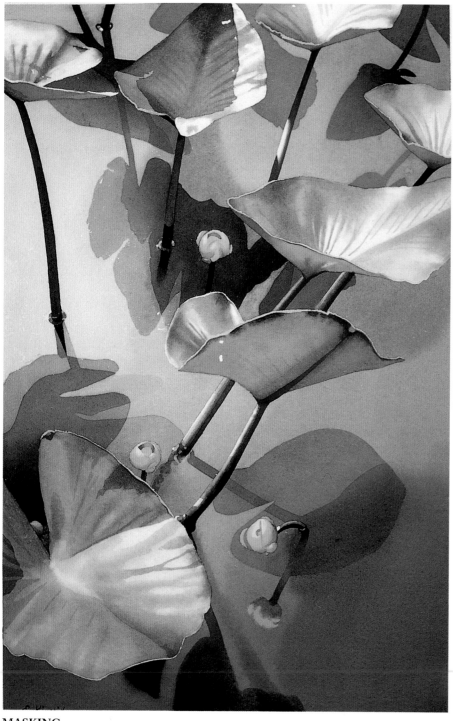

If you are careful with masking fluid and combine it with other masking techniques so it is used sparingly, it can be liberating. I find that my work is much freer when I use masking fluid. I do the meticulous part of my work in the drawing and in the careful application of masking fluid. Then I can use big brushes and paint quickly because I do not have to worry about carefully getting around some little thing. Painting carefully around shapes to protect them is slow work and is more apt to produce uneven washes.

When backgrounds are visually broken up by foreground objects, it can be difficult to keep the background pieces consistent. Doing a graded wash across all the background pieces in just one pass is the easiest way to get a smooth transition. Just be sure you remove excess accumulations of paint and water, which can be caught by the rubber "dams" that masking fluid forms.

There are various kinds of masking materials available to protect large and small areas of pure color. For small areas—dots, slivers and small shapes of all kinds—I use a liquid mask commonly referred to as "Frisket." The use of masking fluid allows me to paint more freely. The downside of masking fluid is that it can abuse the paper. Any time you rough up the surface of watercolor paper in any way, you disturb the sizing that protects it. The exposed core will soak up paint just like a blotter, leaving unwanted stains wherever the sizing is damaged. You will see a difference between areas that have been masked and those that have not.

MASKING

This painting of frog lilies began with masking film protecting the leaves, stems and flowers. After laying down the graded washes wet-into-wet using flat brushes, I glazed the leaf shadows and the reflections of flowers and stems onto the dry paper. Once the water dried, I removed the masking film and covered the small light spots, like edges and small highlights, in the leaves and flowers with masking fluid. I completed painting the leaves and flowers with glazes of Aureolin Yellow, Thalo Blue, Hooker's Green Deep, Ultramarine Blue and Indian Yellow. To finish up and give the painting a full range of values, I darkened the stems with Winsor Violet and Neutral Tint.

Tinicum Treasures
22" × 14½" (56cm × 37cm)

I use masking fluid in stages. I usually put some on the white paper initially and then, after subsequent washes, I may apply more in some places—anywhere I want to protect a pure color. For example, there may be spots of pure yellow in a field of green. I put down a wash of yellow and, when that's dry, protect the spots of yellow with masking fluid. When the masking fluid is dry, I follow with washes of blues or greens. When the masking fluid is finally peeled up, there are spots of yellow amid the green.

Conversely, if there are spots of blue in a field of green, I will apply dots of masking fluid, follow with yellow, remove the masking fluid, and then end with a glaze of blue. Sometimes there will be small areas of a color that is completely different from the surrounding field, for example, a green leaf that has a red or maroon or purple edge. That happens a lot in nature. Nature will juxtapose complementary colors, which, if accidentally mixed together, will make "mud." Masking fluid protects these areas from

each other. When I want to make absolutely sure that a sliver or little spot is absolutely clear red or purple or whatever it needs to be, and it is going to be surrounded by color from across the color wheel, then I use masking fluid to protect that area. I remove the masking fluid when I have completed the surrounding areas and just lay in the color on that sliver or dot with a tiny brush (or leave it white if that is what it needs).

SIMPLIFYING THE STEPS

I've simplified the masking and glazing process to show my technique at its most basic.

1. PROTECT THE LEAF EDGE
I applied masking fluid to the leaf edge with a ruling pen, let it dry, then painted the leaf Aureolin Yellow.

2. PROTECT THE DELICATE LINES
I applied masking fluid to the veins of the leaf and the stems, again with a ruling pen.

3. APPLY THE NEXT WASHES
I painted a light wash of Thalo Blue over the whole leaf and allowed it to dry. Once the entire leaf was dry, I painted another light wash of Thalo Blue over the shadow side of the leaf only. I removed the masking fluid from the veins on the shadow side.

4. DARKEN THE SHADOW SIDE
I painted another light wash of Thalo Blue over the shadow side of the leaf. Once this

area was dry, I removed the masking fluid from the rest of the leaf veins (but not the masking fluid protecting the leaf edge).

5. LAYER THE WHOLE LEAF
I painted a light wash of Thalo Blue over the whole leaf and let it dry.

6. PAINT THE LEAF EDGE
I removed the masking fluid from the leaf edge and painted this area Winsor Red.

Masking to Set You Free

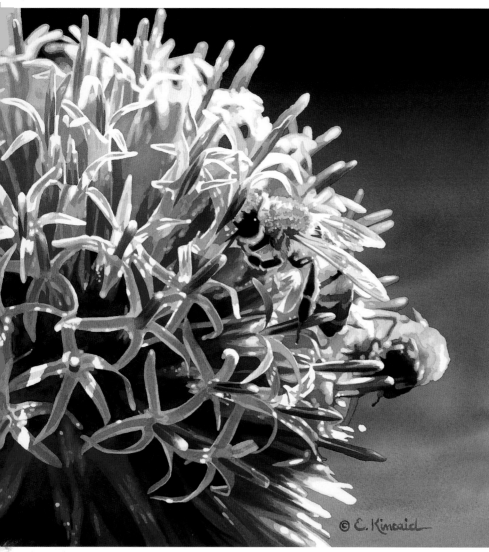

The masking film allows us to use large flat brushes to glaze the graded-wash background. In the step-by-step photos to the left, the untinted masking liquid appears as shiny and light beige. The small spots of masking fluid become placeholders; once they are down, we can find our way through the thistle drawing "maze."

MATERIALS LIST

BRUSHES
1½-inch (38cm) flat
2-inch (51mm) flat
flat scrubber brush
nos. 1-10 round brushes

MASKING MATERIALS
Colorless Liquid Frisket
drafting tape
Frisket Film
permanent waterproof fine-tip marker
scissors
small sharpened brush handle
rubber cement pickup

PAPER
Arches 300-lb. (640gsm) cold-pressed
watercolor paper

PALETTE
Aureolin Yellow
Indanthrone Blue
Indian Yellow
Quinacridone Burnt Orange
Thalo Blue
Ultramarine Blue
Winsor Red
Winsor Violet

THE COMPLETED IMAGE
The bees landing on this globe thistle brought the scene to life for me. Their golden bodies contrast with the violet-blue of the flower to create a vibrant image. Capturing this dance of light and color involved the careful arrangement of masking liquid, masking film and washes of color. To see how the values and composition were arranged, see page 25.

Gift from Marv
13½" ×13½" (34cm × 53cm)

MASK THE FOREGROUND

1 Mask the combined shapes of the globe thistle and bee with masking film and masking fluid. Use large brushes to glaze the layers of color for the dark background. The masking fluid acts as a rubber dam, keeping the paint from seeping under the masking film onto the foreground shape. Once the background is complete, remove the masking film and masking fluid.

PROTECT THE LIGHTEST SPOTS

2 Protect the lightest spots on the bee, the tips of the flower spines and the curving petals with masking fluid (the spots of masking fluid appear shiny here). The masking fluid sorts out the maze of lines, making it easier to find the shapes that need to be painted dark.

ADD THE GLAZES

3 Glaze layers, starting with the darker and smaller shapes. For each successive layer, paint a larger shape and use a more diluted paint. Leave the masking fluid until the color surrounding those areas has the correct value contrast when compared to the other colors.

ADD THE LAST COLORS

4 Once the dark values are deep enough and the other colors are in place and dry, rub up the masking fluid with the rubber cement pickup. Make any final color adjustments and soften edges as needed with the flat scrubber brush.

Taking Care of Masking Fluid

Masking Fluid is vulnerable stuff. It can be easily damaged by exposure to excessive heat or cold and by shaking the bottle. Never leave either a painting with masking fluid on it or the bottle of masking fluid in direct sunlight for any prolonged period.

Once you apply masking fluid to watercolor paper, the subsequent washes should be completed as soon as possible. Never let a painting sit around for long periods of time with masking fluid on it. My rule of thumb is to get masking fluid off within two weeks, preferably within one week. With prolonged exposure to air, masking fluid can turn gummy and form a bond with the paper so strong it is impossible to get off. Paintings can be ruined this way.

Because the ammonia in masking fluid evaporates rapidly, masking fluid forms a skin on the surface when it's exposed to air. You'll need to periodically scoop this layer of skin from your masking fluid container and throw the skin away. When using masking fluid, pour a small amount in the cap from an old masking fluid bottle so the source can be capped up and protected while you work.

The big problem with supplies of masking fluid is that they thicken over time and then it is very difficult to get smooth lines or small, delicate slivers. This thickening is accelerated two ways: leaving the surface skins on the masking fluid after exposure to air and by shaking the bottle.

Never Shake the Bottle!

Masking fluid is a suspension of latex in ammonia. When you shake it, you encourage the latex to come out of suspension. It will gradually form a ball which will float in the liquid, and in the end, the entire bottle of masking fluid will solidify. If you notice a ball, you instinctively shake the bottle to remix the solution, thus setting up a vicious cycle. You would be better off to leave the ball alone or fish it out.

Another motivation for shaking masking fluid is to remix the tint that is often added to masking fluid to help it show up under subsequent washes. The tint has a tendency to settle to the bottom. You should instead remix it more gently, either by simply stirring it or by turning the tightly closed bottle upside down and standing it on its cap for a while. Standing the bottle on its cap now and then will keep the tint evenly distributed. I generally avoid the whole issue by buying untinted masking fluid, which dries to a pale yellow or beige, depending on the brand.

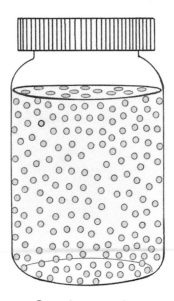

Latex in suspension

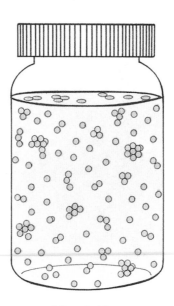

After shaking

After repeated shaking

MASKING FLUID UP CLOSE

The latex suspension consists of microscopic particles of latex floating in ammonia. Shaking knocks the particles into each other and they stick together. Once they've clumped together, the particles won't go back into suspension; it would be like trying to turn butter back into cream.

Waltzing Past Trouble

The biggest challenge with using masking fluid is applying it smoothly. Masking fluid tends to clump, and it can flow unevenly on the rough surface of most watercolor paper. I get around this by drawing a bead quickly along the edge of an area with a fine-tipped tool and then filling in the area behind it. I make sure the masking fluid is thin enough to flow smoothly; otherwise, I throw it away or thin it with ammonia.

Speed is very important in painting and drawing, but even more so when applying masking fluid. Speed not only insures a steady hand but it also means there will be plenty of masking fluid on the paper before it starts to set.

Another characteristic of masking fluid is its tendency to "settle down" after it is applied, spreading outward from where you intend it to be. For this reason, it is helpful to apply it just slightly to the inside of your drawn line and to use a fine-tipped tool.

Watch Your Step!

There is one more problem to be aware of: Sometimes paint gets past the barrier of masking fluid. Usually this happens because the masking fluid hasn't been applied thickly enough, so pile it on generously and avoid spreading it over too much surface area.

When you apply masking fluid, air bubbles can form, drying into tiny pinpricks in the film of latex rubber. These appear almost white in the pale color of the masking fluid. If you see any white spots, apply a second coat of masking fluid.

Masking fluid sets quite quickly. When it is half set, it picks up easily. The skin on the surface will stick to your tool, so use a light touch and avoid direct contact between your tool and the semidry masking fluid on the paper.

A common complaint artists have about masking fluid is that it leaves behind hard edges in the paint. I don't consider this a problem, really. Sometimes these edges may be just what I want for crisp, high-contrast objects in the foreground, for instance. When I don't want hard edges, I either choose not to use masking fluid there, painting around the area instead, or I lift and soften the edges using a variety of tools. No hard edge has to stay that way.

SHOP CAREFULLY

Check new supplies of masking fluid before leaving the store. Don't assume they're in good condition.

- *Tip the bottle gently to make sure the fluid has not solidified.*
- *Watch the liquid as it moves. Masking fluid should flow like cream; if it's more like honey or even thicker, it's too thick. Sometimes thick masking fluid can be thinned with ammonia, but it's better to buy a fresher bottle.*
- *Avoid buying tinted masking materials, especially the darker gray brands. The tinting agents can sometimes stain the paper permanently (although they aren't supposed to do this). Pale yellow masking fluid can also stain, but this tends to be less of a problem because it's lighter. Test new supplies on a scrap of your watercolor paper before risking it in a painting.*

A FINE LINE OF MASKING FLUID

If you need a fine line, use a fine-tipped tool, like the ruling pen shown here, and draw quickly with a light touch. The speed means less masking fluid flows off the tip before you travel on. It's helpful to hold the tool more vertically than you would hold a brush.

I've tinted the masking fluid here to make it show it shows up better in the photograph.

Tools for Applying Masking Fluid

Many tools will work for applying masking fluid. The choice of tool depends on how large an area you need to cover.

The most common tools are inexpensive brushes. Never use expensive brushes, because repeated use of masking fluid destroys them. To slow down the destruction of the brush, soap the brush before dipping it in masking fluid and then wash it in soap and water when you've finished. Because of evaporation, masking fluid tends to clump on the brush while you work, making it difficult to apply delicately. To avoid clumped bristles, wash the brush out occasionally as you work.

To skip all this maintenance hassle, I simply use an old cheap brush that is past saving, and I don't bother soaping it or washing it. Instead, for most applications I use the brush handle, sharpened with a pencil sharpener.

Another favorite tool of mine is a ruling pen. A finely crafted, two-pronged device once commonly used by drafters and illustrators, the ruling pen made controlled ink lines before the invention of mechanical pens. This pen is becoming harder to find in stores but it can still be found in drafting sets.

The ruling pen can make very fine lines, a definite advantage as a tool for applying masking fluid, but any fine-tipped tool will work as well.

When using any of these tools, it helps to hold them vertically, as you would hold an oriental brush for calligraphic work. The masking fluid seems to flow easier this way, especially if you use a light touch.

Experiment With Tools

Actually, there are many easy-to-use tools for applying masking fluid: speedball drawing pens, sticks, "oilers" (small squeeze bottles with needle-nose tips), and the Incredible Nib, now on the market. Experiment to find out what works best for you.

I sometimes create splatters of masking fluid with an old toothbrush I keep for this purpose. The toothbrush cleans up easily with soap and water, but more importantly this technique adds an interesting element of texture to my layers. By glazing across an area of masking fluid dots, removing the masking fluid and glazing again, I can create an area of light-colored dots within a darker field. The possible variations are endless.

Another important tool is a rubber cement pickup, a small square of gum shoe sole material sold in most art supply stores. With this, you can easily remove dry masking fluid once the surrounding paint is thoroughly dry. The less scrubbing of the paper you do the better, so try to rub one end of any long strip of dried masking fluid and peel the rest up in one long "rubber band."

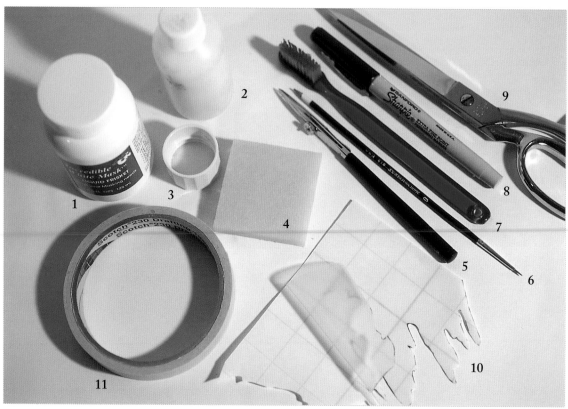

1. masking fluid
2. ammonia (clear only)
3. old masking fluid bottle cap
4. rubber cement pickup
5. ruling pen
6. paintbrush handle, sharpened
7. toothbrush
8. permanent waterproof fine-tip marker
9. scissors
10. masking film
11. drafting tape

MASKING TOOLS

Working With Masking Fluid and Masking Film

Masking fluid can lift some of the drawing off the paper, so you will need to draw again. This is not a problem in small areas, but it is for large complex drawings.

To avoid this problem (and avoid damaging the paper), use masking film. This film is a pressure-sensitive, translucent film with a paper backing and is used in airbrushing.

Work quickly and smoothly when applying masking fluid, because it will flow into the valleys in the watercolor paper, creating lumpy lines, or will leave air bubbles for paint to bleed through. Use long even strokes that overlap, and avoid spreading any one load of masking fluid too far. Draw a long thin bead along the drawn edge and then fill in the remaining area right afterwards with heavier applications before the bead has had a chance to dry. After the masking fluid is dry, be sure to check the whole area carefully for places that you missed or that are too thin or that have air bubbles. Add another layer where necessary—just be sure the first layer is completely dry before you do.

For this demonstration I decided to paint pygmy goats. After selecting the image, I arranged it and transferred it to the watercolor paper.

MATERIALS LIST

BRUSHES
Toothbrush
1½-inch (38mm) flat
2-inch (51mm) flat
nos. 1-10 rounds
flat scrubber

MASKING MATERIALS
Frisket Film
colorless liquid Frisket
permanent waterproof fine-tip marker
scissors
drafting tape
small sharpened brush handle
rubber cement pickup

PAPER
Arches 300-lb. (640gsm) cold-pressed
watercolor paper

PALETTE
Indian Yellow
Transparent Brown Oxide
Transparent Red Oxide
Ultramarine Blue
Winsor Violet

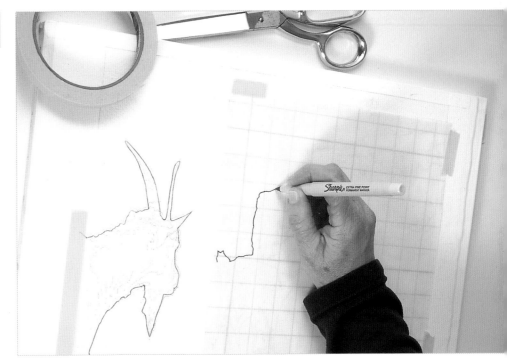

APPLY THE MASKING FILM

1 Attach the masking film loosely to the drawing with drafting tape. Use a permanent fine-tip marker to trace the shape that you want to protect. Draw the line about ¹⁄₁₆ inch (2mm) inside the pencil outline on the watercolor paper. Use scissors to cut out the shape on the film, and leave a small amount of the marker line showing in order to see where the edge of the film is later. Then peel off the backing and lay the film sticky-side-down within its corresponding shape on the watercolor paper and smooth it out. It has the stickiness of a Post-it note and won't damage the paper.

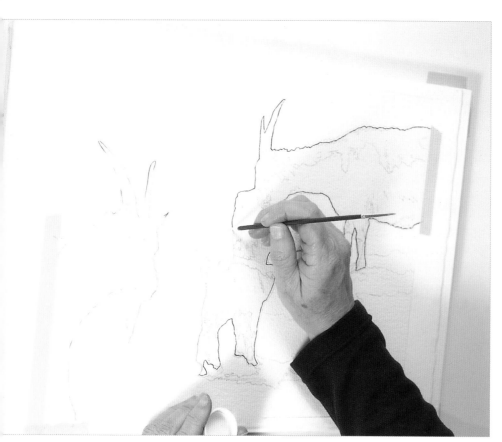

APPLY THE MASKING FLUID

2 Fill in the gap between the edge of the film and the outline of the shape on the paper with masking fluid, using the small, sharpened brush handle. Overlap the masking fluid onto the film so it's completely sealed in, with the marker line running down through the center of the masking fluid band. This method seals large masses without covering the whole surface with something that will damage the watercolor paper or lift the drawing. Masking film by itself won't fully protect the paper from the watery washes that will come later—it needs the help of the masking fluid.

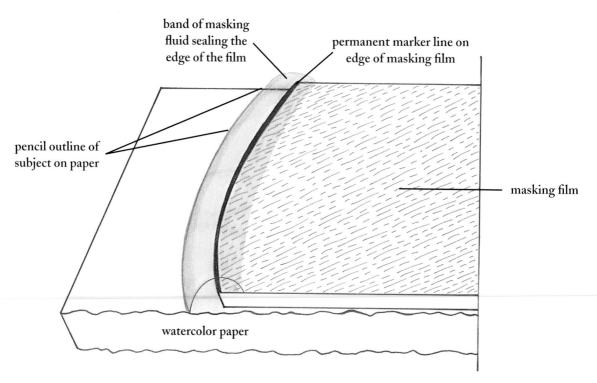

band of masking fluid sealing the edge of the film

permanent marker line on edge of masking film

pencil outline of subject on paper

masking film

watercolor paper

ENLARGEMENT OF PAPER, MASKING FILM AND MASKING FLUID

CREATE TEXTURE

3 To create texture for the ground under the goats, dip a toothbrush in masking fluid and then splatter it by rubbing your finger along the bristles. This technique is great for creating uneven ground cover, like dirt, mulch or pebbles. To suggest hay, draw lines of masking fluid with a fine-tipped tool.

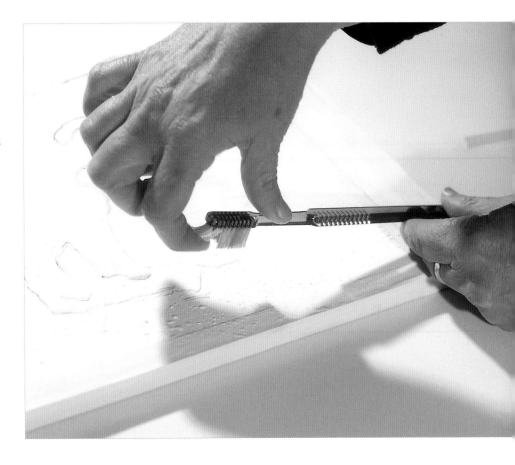

SPLATTERING

You can create interesting texture using various brushes to splatter paint or masking fluid.

When splattering with a paintbrush, one way to maintain some control of the pattern is to knock the loaded brush against your finger. Splattering with a paintbrush can create gestural strokes and expressive marks, as well as texture.

You can create wilder and more expressive patterns by simply flicking the loaded brush; flick your wrist the way a fly fisherman does when he casts a line. Don't forget to protect surrounding surfaces from the splash!

To create splatter texture with a toothbrush, first begin with a graded wash. Washes need to be painted first, as washes painted over splattering will lift color and soften the pattern, perhaps too much. The first layer of splatters is masking fluid, which will leave white dots once the paint has dried and the masking fluid is removed. Layers can be built up using the same palette of colors you would use to mix a wash for the area. Splatter one color, let it dry, then splatter the next color.

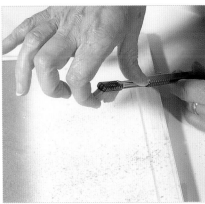

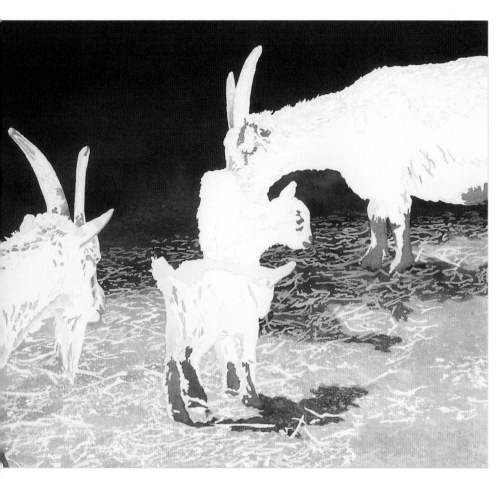

PLACE THE FIRST LAYER OF MASKING FLUID ON THE GOATS

4 Once the background is complete, peel up the masking materials. Applying masking fluid and paint in alternating layers is a technique that can also be applied to animals. Mask the lightest hairs and any white spots with masking fluid first.

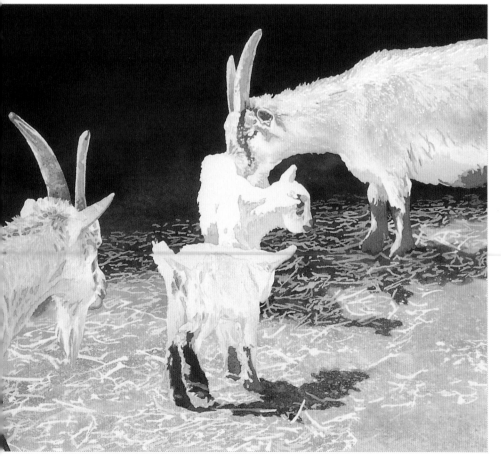

PAINT THE DARKEST AREAS AND THE FIRST WASH

5 Paint the darkest spots with Transparent Brown Oxide, Ultramarine Blue or Winsor Violet, then allow them to dry. Use those three colors plus Indian Yellow to paint the first light washes over the whole goat. If you want any spots to be the value of this first wash, protect them with masking fluid. The shine of the masking fluid shows where the goats' hair is saved as brown, yellow, blue or violet. This allows you to paint the next layers with larger brushes and still protect those hairs and dots of light color.

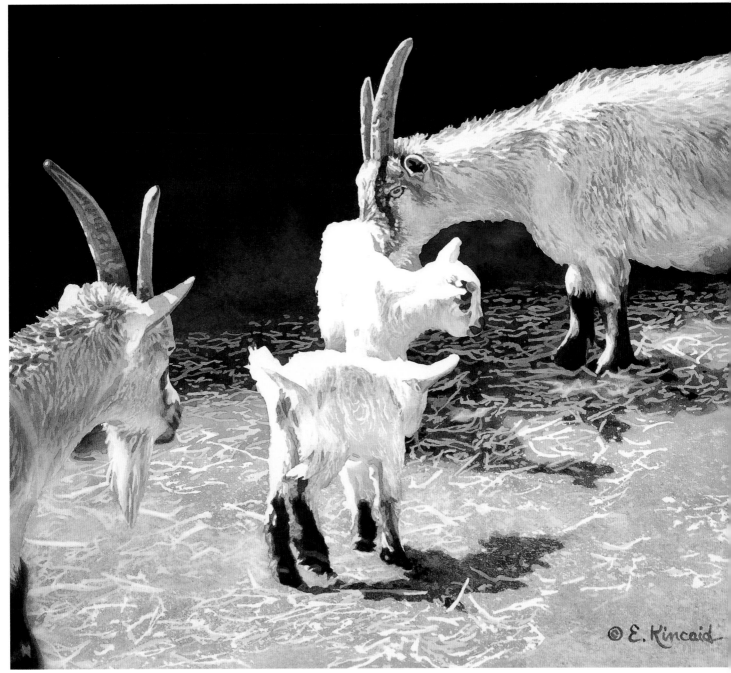

Kids and Moms
10½" × 14½"
(27cm × 37cm)

ADD THE FINAL LAYERS

6 Continue to build up the darker areas, letting everything dry between layers. Glaze a second light wash over the whole area, introducing Transparent Red Oxide. Let this dry ,then apply masking fluid to any area of the Transparent Red Oxide you wish to protect, like for a few light red hairs. Continue alternating between washes of color and masking until there is enough detail to create a convincing surface texture. Remove all the masking fluid with a rubber cement pickup. Glaze where needed, then soften the edges with a flat scrubber and adjust the values.

© E. Kincaid

WATER IN WATERCOLOR: A BALANCING *Act*

Watercolor dances because it flows in water. Living near the water all my life, I have watched water ebb and flow, and I have watched the traveling "passengers" floating along. Always moving and always changing, water makes the painting experience dynamic and exciting— just like life!

Oahu Gold
10½" × 14½"
(27cm × 37cm)

How Paint and Water Interact

Painting in watercolor is a matter of balancing the relationship between water and paint both in the brush and on the paper. This ratio is affected by the amount of water in the area, the humidity of the air, and whether there is wind or sun to suck up water. Working in this medium is a dance with water and paint and paper.

To get the same result, there are two options: Wet the paper and then apply paint or paint, dry paper with a brush loaded with a larger proportion of water to paint.

Wetting the paper first aids in the flow and blending process, giving you more time to work because the extra water takes longer to evaporate. You can blend paint on dry paper, stroking back and forth, each brushstroke overlapping the one before, almost like mowing a lawn, but *speed* is very important. Paint sinks into the paper as you work, and slower brushstrokes can leave individual brush marks instead of a smooth wash.

OPTION A

Wet the paper first, then load the brush with paint mixed with a small amount of water. This technique will give you a very smooth wash.

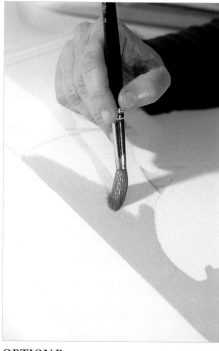

OPTION B

Paint directly on dry paper. Use a brush loaded with paint and more water than in option A. It's more difficult to produce a smooth wash with this technique, but applying the paint to dry paper has the advantage of producing a more predictable intensity of color. Also, it is less likely to lift any underlying glazes. Use this method for smaller shapes and when floating a glaze on top of a multilayered area.

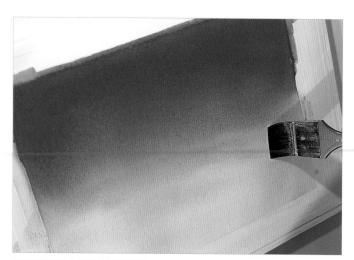

PAINTING ON A SLOPE

For larger washes, painting on a slope helps the paint to blend. Economy of motion and laying down an even pattern of strokes will create a smoother wash. The fewer brushstrokes, the smoother the wash.

REMOVE EXCESS WATER

While gravity is helping the wash strokes to blend, do not touch! *Use the time instead to remove any pooling water from around the edges of the wash with a tissue.*

Get the Results You Want From Paint Behavior

Wetting the paper with paint and water is like re-creating an ocean full of sediment in microcosm. As the water in the painting dries, the area becomes like the mud flats an ebbing tide leaves behind. Water seeps across, but not as rapidly as it moves when the tide is in. Paint floats in the water the way sediment floats in a lake or seaweed and driftwood float in the sea. Paint travels to the edges of its "lake," gradually falling to the bottom as it goes. If the water is shallow enough, the sediment, or paint, will settle evenly all over because it doesn't have time to travel too far before the water evaporates. Any part of the overall area that collects more of the paint granules before the water evaporates will be darker.

EXCESS WATER
If the amount of water laid down is disproportionately large to your surface area, a dark line of color will form around the circumference as the water evaporates.

EFFECTS OF GRAVITY
The traveling of the paint and water can also be affected and even controlled by gravity. When the paper is tilted, paint pools toward the bottom of the dampened area. To avoid any darkening, lift the excess off with a brush or tissue before the area dries.

HANDLING EXCESS WATER

AVOID THE EDGE
Blot the area with a thirsty brush or the edge of a tissue to remove excess water wherever it pools.

PREVENT THE EXCESS
An even better approach is to keep a wad of paper towels by your painting at all times. Touch your brush to the paper towels before painting in order to prevent any excess water from leaving a dark edge.

Watermarks

Watermarks, or "blossoms," are a frequent consequence of water imbalance. Once you lay down a passage of paint, a certain window of opportunity is set up—a length of time determined by the thickness and quality of the paper, the dryness of the air, and how much water is applied to the surface. As the water evaporates, the lake becomes more and more shallow until it leaves mud which, if left undisturbed, dries hard. When the lake is still deep, you are free to stir it around, add more paint or water, and lift paint and water. As it dries, the paint settles to the bottom and forms a soft layer of sediment that is vulnerable to disturbance. Touching it at this stage with a brush will leave a mark in the mud, not only picking up the paint but also shoving it aside, leaving unwanted concentrations.

High-Tide Watermark

Adding too much water to a semidry wash will be like the tide coming in on the ocean shore. The added water will pick up the soft sediment and carry it up to the new "shoreline" within the drier wash. This makes the watermark. It is possible to add or lift paint at this semidry point in a painting, but use only a very dry brush so that you don't add new water.

Where Watermarks Occur

Watermarks are a common problem when painting adjacent areas in quick succession. The simplest way to avoid them in this case is to leapfrog around a painting while working and avoid painting next to drying areas.

Watermarks also appear along the edges of paintings. When water is brushed over the edge onto the tape and not lifted with a thirsty brush or tissue, it will frequently flow back into the painting. The drying paper acts like a sponge. For this reason, it is a good idea to mop up any excess water left around the perimeter of a painting right after applying washes. Also, if you prop the painting up at a certain angle when creating a wash, keep the board at that same angle while everything dries to prevent backwashes.

USING WATERMARKS

Watermarks can be a problem when they happen by accident, but you can also use them for textural effects. They are especially fun in loose, abstract backgrounds where you want to suggest action without describing detail. Lay down a wash, wait until the shine is disappearing, then drop water or paint diluted with water onto the surface. You can randomly scatter them in by splattering

Here, I've laid down a stroke of Indian Yellow on wet paper. After that dried, I washed the area with clear water again, then added Quinacridone Burnt Scarlet. When the shine began to disappear, I dropped in clear water from the tip a of a brush. The blossoms cut holes through the scarlet to the underlying yellow or to the white paper.

WATERMARKS

Watermarks, also called blossoms, are the result of a water imbalance. If there are two areas of paint next to each other—one slightly damp and the other very wet—the drier area will attract the water loaded with paint.

TIDAL WATERMARK

The pileup of pigment on paper is like seaweed, driftwood and other debris washed up and left by the high tide.

WATERMARKS AS TOOLS

In Magnolia Next Door, *a pattern of small "blossoms" gives the impression of detail in the background without giving any real information. The background's soft suggestion of detail grounds the image in reality but won't distract the viewer from the subject.*

Having decided on Thalo Blue for the background, I painted sweeping brushstrokes of the color wet-into-wet. I framed the buds with the darker color, leaving a lighter area from the middle of the painting toward the upper-right corner. As the wash began to dry, I glazed and splattered the paper with clean water, flinging it from a small brush and then letting everything dry. I glazed and splattered it one more time with clean water to increase the sense of movement.

Magnolia Next Door

21" × 13½" (53cm × 34cm)

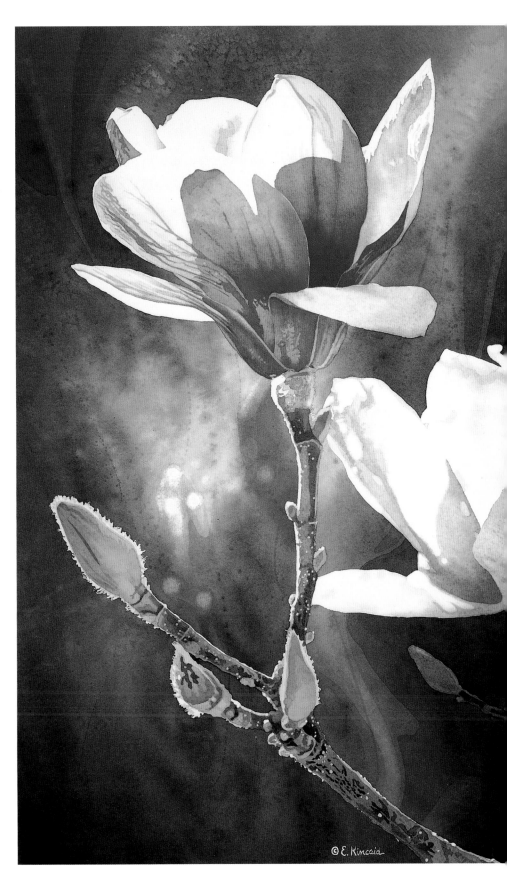

When making a soft blended wash with glazes of several colors in varying intensities, wet the whole shape each time, even when applying paint to just part of the shape.

Controlling the Water

There are a number of ways to control water on the painting surface. The first way is simply with time: After wetting the area you wish to paint, just wait until the shine has almost disappeared. The color travels slower through drier areas and won't travel as far.

To remove water once the wash is down, delicately touch a tissue to the surface or wipe the area with a natural sponge (one firmly squeezed to remove any excess water).

Some artists prefer to work with a thirsty brush. Simply wet the brush and then wipe it dry so that it is moist but drier than the paper. Draw the brush along the surface to pull up the excess moisture. To increase exposure to the drier bristles, roll the brush along the damp areas. Tilting the painting board before beginning to paint will direct all the excess water and paint to one place at one edge.

Allow the Glaze to Dry

When working with glazes, it's important to allow time for the paper to dry thoroughly before moving to the next stage. It may look and feel dry, but if the paper is cool to the touch, let it dry a little longer. You risk picking up paint from the previous layer and creating a muddy situation if you proceed into an area that only appears dry.

It also helps to use a light touch with the brush. Don't scrub or press down into the paper with the brush, as this will pull up paint.

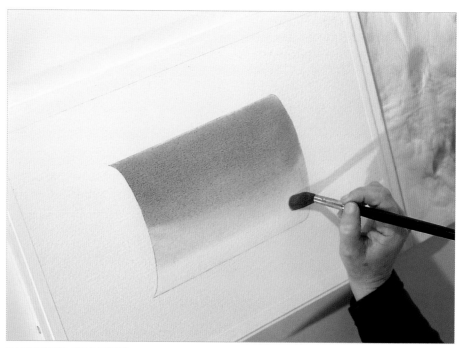

PAINTING AT A TILT

To paint a graded wash wet-into-wet on an inclined slope, place the end you intend to be darker at the top. Begin painting there, then let gravity help carry the paint down. Lighten the wash by using a clean, wet brush to blend the paint downward.

STAMPING

Stamping, familiar to many people from childhood art classes, is a classic technique. You can build up layers of different colors quickly and create distant trees, ground textures and rocks.

With watercolor, I find the natural sponge is the ideal stamping tool because its irregular shape produces a wonderful texture. Simply stir water and paint to the right intensity on your palette, dip the sponge into the paint and stamp the paper.

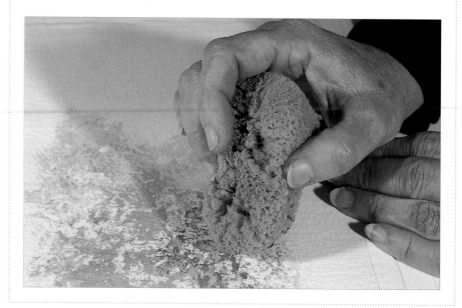

Make a Smooth Glaze

The secret to creating a smooth glaze is to use the largest brush you can handle and to paint your wash of color with the fewest strokes that you can. The surprise comes from discovering that each layer in a stack of glazes can have some imperfection, yet the final result can be perfection!

MATERIALS LIST

BRUSHES
no. 10 round

PAPER
Arches 300-lb. (640gsm) cold-pressed watercolor paper

PALETTE
Cadmium Red Orange
Indian Yellow
Winsor Red

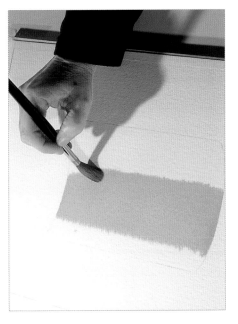

START WITH A LAYER OF THE HIGHEST VALUE

1 To paint a cylinder with color grading from pale yellow to deep red, first paint the whole shape with clear water. To create a burst of yellow in the center of the cylinder, start with the board tilted so that the cylinder is upright on the paper, then lay in the Indian Yellow at the center. The paint will naturally spread across the wet surface and will be balanced side to side. Stroke the edges of the Indian Yellow with a clean wet brush as the paint flows to the edge. This will help create a more even gradation.

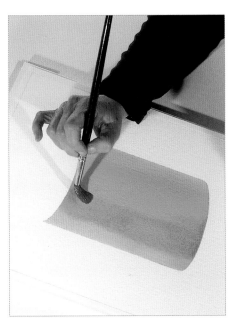

ADD THE MIDDLE VALUE

2 After the Indian Yellow dries, wet the whole area again. Paint a stroke of Cadmium Red Orange at the center of the area you intend to be darkest, but don't allow the Cadmium Red Orange to travel as far as the Indian Yellow did. Control the spread of the color by reducing the amount of water in the paint-filled brush (touch the paper towels!) or by lifting water from the lake in the path of the travel with a thirsty brush.

END WITH ONE STROKE THE LOWEST VALUE

3 Wait for the area to dry and then apply a third coat of water. Once the entire cylinder is wet, brush a single stroke of Winsor Red through the center of the Cadmium Red Orange. Don't allow the Winsor Red to travel very far; it needs to stay contained in order for the orange and yellow bands to show.

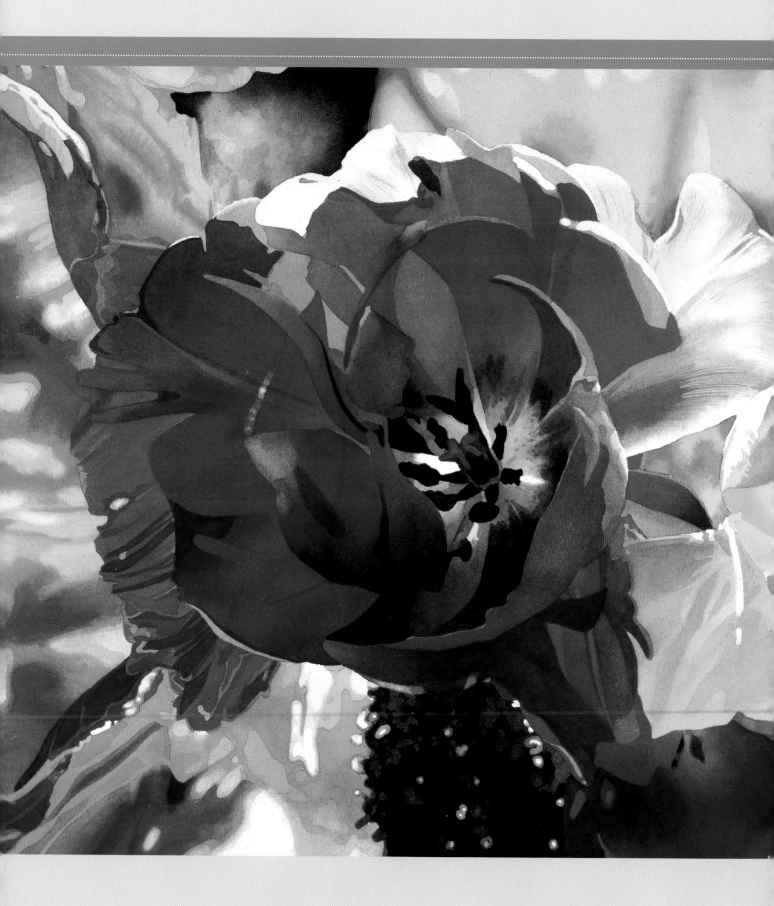

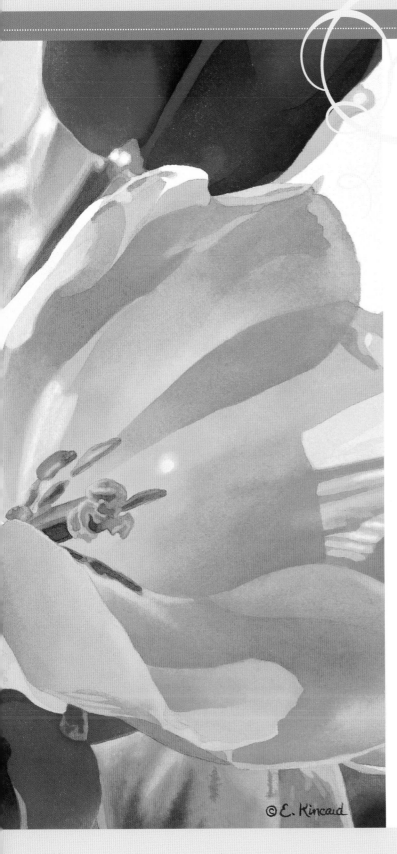

COLOR:
MAKING VISUAL
Music

Color makes living in this world a rich and rewarding experience. Create harmony and bring your paintings alive by playing with the full range of color possibilities. Color is a symphony.

Ria's Bouquet
13½" × 21"
(34cm × 53cm)

©E. Kincaid

Understanding Hue and the Color Wheel

The color wheel arranges the colors of the spectrum so you can see their relationships clearly. Before we discuss the organization and relationships of the color wheel, we need to understand the properties of color. Color has three characteristics: hue, value and intensity. By varying one or all of these characteristics we change colors. Hue is the color's name, like red or blue-green. Value is how light or dark a color is. Intensity refers to how saturated or strong a color is. Basic color wheels are arranged by hue.

Temperature

Hues have temperatures. Colors approaching red or yellow are warm and aggressive; they come forward on the picture plane. Those nearer blue are cool and reticent; they seem to recede into the picture.

Primary Colors

There are three primary colors: red, yellow and blue. Using these primary colors, it is possible to make all other colors. Each primary color on your color wheel should have a warm and a cool version.

Complementary and Secondary Colors

Each color on the wheel has a complementary, or opposite, color: red's complement is green, blue's complement is orange, and yellow's complement is purple. The complement of each primary color is a secondary color, which is made by combining two primary hues. Red and yellow make orange, yellow and blue make green, and blue and red make purple. These relationships are important because complementary colors have a strong impact on each other. If you place complementary colors side by side, they increase the apparent intensity of each other. A small amount of red adjacent to green in an otherwise green painting will make the red seem brighter and stand out more.

When you mix complementary colors on the palette or in glazing layers, they dull each other or reduce the intensity. The resulting mixture will be some variety of an earth color or gray, depending on the proportions used. These more neutral colors are useful if that is the result desired, but a disaster if it is not.

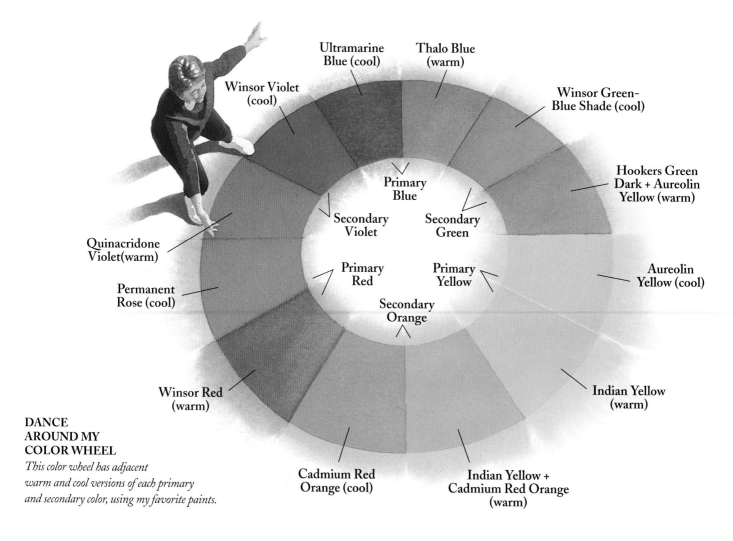

DANCE AROUND MY COLOR WHEEL

This color wheel has adjacent warm and cool versions of each primary and secondary color, using my favorite paints.

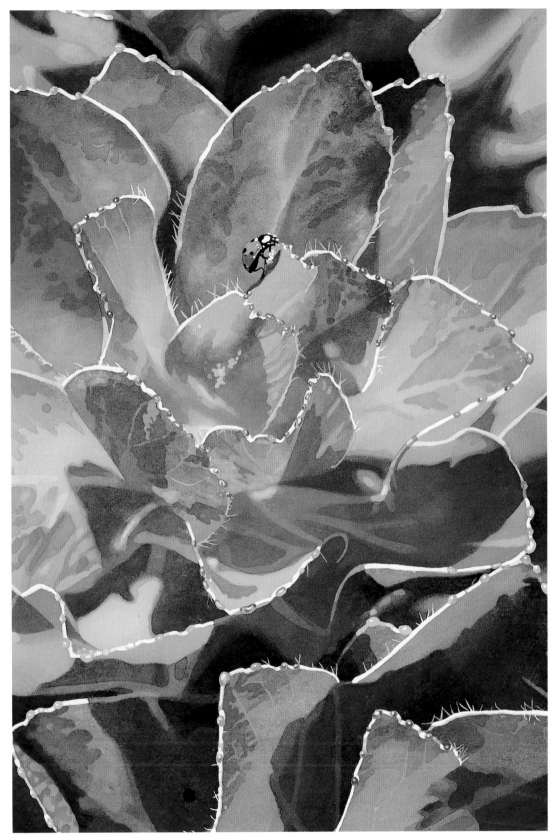

PAINTING WITH COMPLEMENTARY COLORS

This painting is a field of greens. The red and orange balls along the white leaf edges are what bring this image alive. The contrast is enhanced by the complementary colors. The ladybug landing was pure serendipity!

Ladybug World
21" × 13½" (53cm × 34cm)

Subtle Colors

Learning the subtleties of color is important because objects in nature rarely display just a few tube colors. There is an infinite number of naturally occurring colors to be made or suggested by juxtaposing colors. As you become familiar with color mixing and glazing, you will be able to analyze an object for its color components and see the proportions involved. Understanding these components is also important when you want to play with or alter the color. As an artist, you are not bound to reproducing the world the way it really looks.

Grays

In my paintings, I avoid using grays. Instead, I look for some temperature bias in gray subjects. If the color is a blue-gray, I use blue. If the subject is a warm gray, I paint it a golden or reddish brown, or maybe a violet or green. These choices add vibrancy to my paintings.

If you choose to use grays, layering complementary colors is a far more interesting and colorful way to create gray than mixing white and black or diluting black with water. Complementary grays have *life* in them.

Although gray is a neutral color, it is rarely completely balanced in temperature. Gray is usually either warm or cool. You can make grays by layering some combination of colors that contain red, yellow and blue; the proportions will depend on whether you need a warm or cool gray. You can learn a lot about the subtleties of glazing color by trying to make a neutral (unbiased) gray by glazing red, yellow, and blue.

Black

Black has a contribution to make in painting—it establishes strong contrast and boldness. Whether you mix black from other colors or get it straight out of a tube, it has a great deal of power. There's a risk in using the tube blacks, like Ivory Black or Lamp Black. These blacks have a deadening effect when used for light- and middle-value washes. When creating dark values with tube blacks, you need to use them strongly or layer deep, strong colors underneath to establish temperature bias. Indanthrone Blue or Indigo can make a strong black, especially when layered with another color, and, when used alone, provides a strong blue bias that gives life to the resulting dark area.

Brown

The different tube browns are made using different chemical components. Try matching the tube color browns by mixing your own from primary colors; it will help you understand the behaviors of the different browns. You'll find that gray is simply a brown that has a little more blue added. The more blue you add, the cooler the gray.

White

I don't use white paint, except to sign my name if the signature area is dark. Instead, I use the white of the paper to create the bright whites in my paintings (see chapter seven).

**Ultramarine Blue +
Transparent Red Oxide**

GLAZING BROWNS
You can glaze Ultramarine Blue with Transparent Brown Oxide or Transparent Red Oxide to create a variety of browns, grays and blues. These are useful combinations for creating earth tones, neutrals and darks in landscapes and wildlife paintings.

**Transparent Brown Oxide +
Ultramarine Blue**

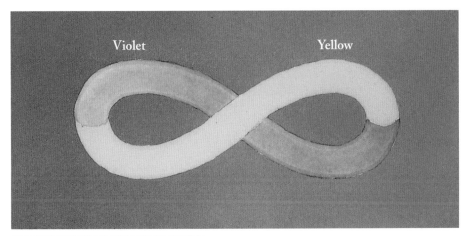

GRAYING WITH COMPLEMENTS

Each of these examples shows a pair of complementary colors surrounded by a neutral background. I have painted the background for each complementary pair with glazes of those two colors. I applied a graded wash of each color, starting at opposite ends. This creates a concentration and dominance of one color at each end and something closer to gray in the center, where the two colors are glazed equally. When complements are similar in value and juxtaposed, they seem to shimmer.

Color Temperature and Perspective

Color has temperature. Adding red or yellow to an existing color will warm it up; adding any blue will cool it. Color temperature is important for you to understand because temperature has power. Cool or grayed colors tend to move back in space, while warm or intense colors tend to advance.

An understanding of relative temperature allows you to manipulate the illusion of space on flat paper. Color temperature, relative values and the hardness or softness of edges make up the components of atmospheric perspective. To create the illusion of three-dimensional space, remember that warm colors come forward while cool colors recede and that as objects move into the background, they weaken in value and their edges become softer or out of focus. When combined with linear perspective, atmospheric perspective creates the illusion of real space. Leaving out any of the perspective components tends to flatten the image and reduce depth.

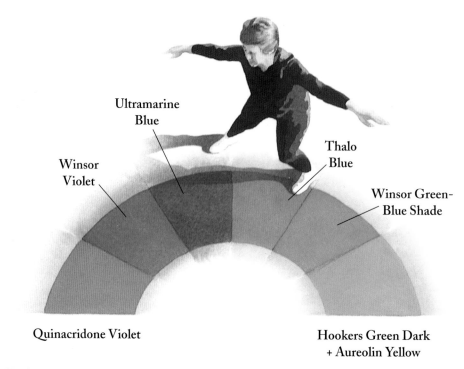

Ultramarine Blue

Thalo Blue

Winsor Violet

Winsor Green-Blue Shade

Quinacridone Violet

Hookers Green Dark + Aureolin Yellow

KNOW YOUR COLOR TEMPERATURES
As you travel on the color wheel from blue toward either red or yellow, color becomes warmer. On this wheel, the coolest spot is between Ultramarine Blue and Thalo Blue because Ultramarine Blue has a slight red bias and Thalo Blue has a slight yellow bias.

ATMOSPHERIC PERSPECTIVE
The field behind Bo becomes increasingly blue and the value contrast between elements is reduced as your eye moves into the background. These color shifts create the illusion of real space on the paper.

Bo
10½" × 14½" (27cm × 37cm)

Dominant Color Temperature

Choosing a dominant color temperature will produce a strong painting. An equal division between warm and cool colors can be just as static as having equal-sized shapes and spaces. In addition, too much of any one thing tends to weaken its impact.

Color can also inspire emotion. Blue can feel serene, yellow can feel cheerful, and red can feel passionate or active.

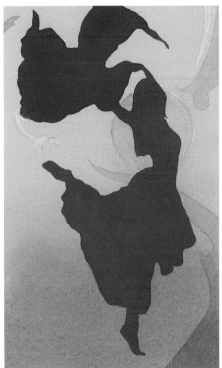

THE IMPACT OF CONTRASTING TEMPERATURE

A painting done entirely in shades of red, brown and yellow is very warm. Adding a few touches of cool blue can enhance the overall perception of warmth and give the blue a great deal of power.

GOLDEN HORSE BATHED IN SUNSHINE

With background colors of Indian Yellow, Red Oxide and Sap Green, the young golden brown horse seems to dance in the sunlight. The bits of blue sky enhance the overall warmth of this fall afternoon.

Little Joe
13½" × 21" (34cm × 53cm)

BLUE ON BLUE

In contrast to the warm color temperature dominance of Little Joe, *this painting takes its cue from the iris. The background also reflects this with cool Winsor Green and Thalo Blue, Ultramarine Blue and Winsor Violet. The touches of warm, soft reds, Aureolin-based greens, and light Indian Yellow washes enhance the coolness, invoking the freshness of a spring morning.*

Two Blue
13½" × 21" (34cm × 53cm)

Value and Intensity Defined and Explained

The value of a color is its lightness or darkness, as if on a scale from white to black. Each color has its own inherent value and a capacity for a limited range of values. For example, yellow can be very pale but never truly dark, while blue can be very pale and also very dark. Value changes can define form, indicate where light is coming from as it falls on an object, and evoke a mood. Value contrasts create the sense of light in a painting.

When painting with watercolors, the proportion of water to paint in the brush and on the paper can alter the value of a color. Adding a darker color can also change value. You can do this either by glazing transparent washes of pure unmixed color or by mixing colors on the palette. You can use white paint to lighten an area or to create highlights, but this adds a milky, opaque effect that is not as lively as using white paper for highlights or lifting paint off to lighten an area.

Intensity

Intensity, also called chroma, describes the purity of a color in terms of its brightness or dullness. A hue of high intensity appears vivid and saturated; it has not been lightened with water or darkened with black, and it appears on the outer circle of the color wheel. A low-intensity color will appear more neutral—complementary colors mixed together. In other words, a low intensity color appears grayed.

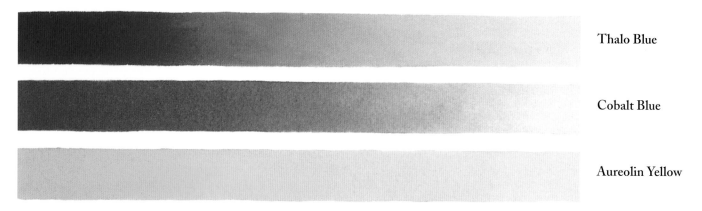

Thalo Blue

Cobalt Blue

Aureolin Yellow

EACH COLOR HAS ITS OWN VALUE RANGE
Thalo Blue has a broad range of value possibilities, Cobalt Blue somewhat less. Aureolin Yellow has a very limited value range. A small value range becomes a challenge when you need to create enough value contrast to show light and shadow effects.

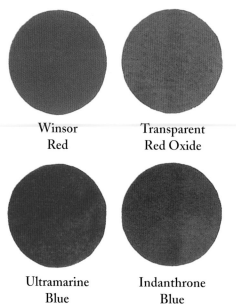

Winsor Red

Transparent Red Oxide

Ultramarine Blue

Indanthrone Blue

SELECT THE CORRECT COLOR AND INTENSITY
Pigments vary in their intensity. Winsor Red is very intense, while Red Oxide is much more subdued. Ultramarine Blue is more intense than Indanthrone Blue. You can reduce the intensity of a color by adding some of its complement or choosing a less intense paint.

DARKENING VALUE
Glazing Quinacridone Violet over Thalo Blue creates a deep, rich dark, one of my favorite color recipes!

Maintaining Intensity

Imagine yourself able to travel around the color wheel whenever you have a question about which color to use. In order to preserve your hues and keep your colors bright, avoid layering colors that dull each other. To prevent dulling an area, you want to avoid glazing complementary colors. You also want to avoid layering all three primary colors; when added together, red, yellow and blue make brown or gray. When you combine complementary colors, you actually combine red, yellow and blue. Any mix of the three primaries will create a neutral gray, brown or olive green. Therefore, stick with just two primaries if you want something other than a gray or brown. Conversely, if you want to create earthier (browner) or grayer versions of colors, use all three primaries.

To maintain the intensity of color in your painting, use colors that are adjacent to each other on the color wheel (these are often referred to as analogous colors). You can use these neighboring colors to alter a particular hue in two ways: Glaze one color on top of another, or paint these colors side by side in your painting. Using these methods, the colors act as an orchestra instead of just one instrument.

Permanent Rose

Aureolin Yellow

Indian Yellow

Winsor Red

Cadmium Red Orange

Indian Yellow + Cadmium Red Orange

USE THE COLOR WHEEL AS A GUIDE

If you want to maintain the intensity of a color in your painting, look at the part of the color wheel that most closely matches that color. For instance, if your color is orange and you want to maintain its brilliance, you need to limit how far around the color wheel you travel away from orange to find the colors you'll use to glaze. You can move in either direction around the wheel. You can use any of the reds or yellows, but stop short of any color with blue in it. The colors that surround orange are its analogous *colors. In this example, you can add anything from orange to red, but not a bluish red. Any yellow can be added, but not a yellow green. On the other hand, if you want an olive green or earthy orange, going beyond bluish-red or yellow-green is necessary.*

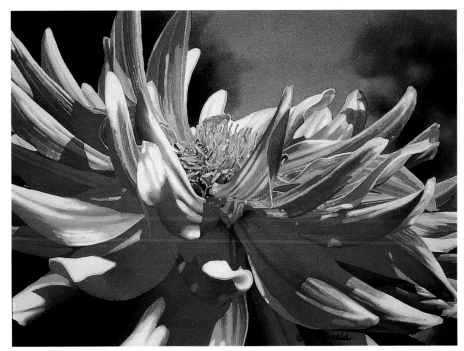

GLAZING WITH NEIGHBORING COLORS

A red flower might have a series of connecting shapes painted in a succession of Winsor Violet, Anthraquinoid Red, Winsor Red, Cadmium Red Orange and Permanent Rose.

Dahlia Fire
10½" × 14½"
(27cm × 37cm)

The Properties of Paint

Before doing your first color painting, you need to become thoroughly familiar with the properties of your own palette—the paints you've selected. There are some basic colors most artists have, but everyone collects extra colors that meet their own needs. Color is a personal thing. I continuously experiment with new pigments.

Each tube of paint has many qualities besides its particular hue, and these char-acteristics are important to consider when choosing a paint. Some colors stain the paper, and others that sit on the surface and are easier to remove. There are transparent colors and opaque ones. The differing properties of paint come from their differing originals and chemical formulations. Transparency is especially important in my work since I depend on being able to see through the top layers to the bottom layers.

Nonstaining, Opaque Pigments

Inorganic pigments are generally opaque and nonstaining because they are made from synthetic ground rocks and dirt suspended in gum arabic and water (basically manufactured mud!). Inorganics like the cadmiums, oxides, earth colors, ultramarine, and carbon black have low color strength and a high index of refraction. This means that the light bounces back and forth while traveling

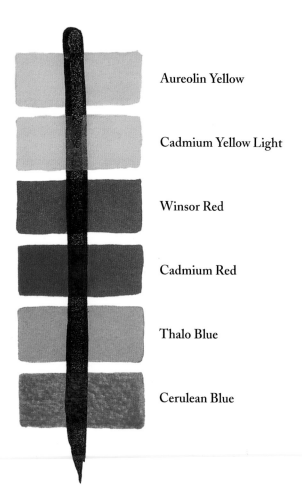

Aureolin Yellow

Cadmium Yellow Light

Winsor Red

Cadmium Red

Thalo Blue

Cerulean Blue

TEST FOR TRANSPARENCY

Place a band of permanent India ink on a piece of watercolor paper. Paint full-strength strokes of your colors over the dried India ink. Allow the paint to dry. If the black of the India ink shows through clearly, then that paint is transparent.

Here I have contrasted Aureolin Yellow with Cadmium Yellow Light, Winsor Red with Cadmium Red, and Thalo Blue with Cerulean Blue. These colors were used close to full intensity. Of course, opacity of watercolor paint is relative—any paint will become more transparent if diluted enough.

TRANSPARENCY COMES FIRST

The luminosity of the greens came from first glazing transparent Aureolin Yellow where the greens would warm. After establishing the range of dark and light greens with glazes of transparent, staining Thalo Blue, I glazed final layers of diluted, opaque, nonstaining Sap Green for areas that were to be very warm or olive green. I left Sap Green for last to avoid glazing over it; this paint lifts easily and would have traveled to where it didn't belong.

Ranunculus Gold
14½" × 10½" (37cm × 27cm)

through the suspended particles and can't pass through. The earth colors—Yellow Ochre, Sepia, Indian Red, etc.—historically were literally dug from the earth and tend to be opaque, sedimentary and easy to lift off the paper. Most earth colors now are made from synthetic iron oxide pigments.

Staining Colors

Staining colors are usually made from organic dyes and tend to be transparent, but not all dyes are staining. Permanent organic pigments are synthetic. They tend to be transparent because their index of refraction is low and their color strength is high. This means light passes through them to bounce off the paper, and a small amount of paint will produce an intense color.

The difference between transparent and opaque watercolor is like the difference between gelatin and mud! Transparency and opacity are important considerations. Opaque, nonstaining colors are popular with many watercolorists because they mix colors on their palettes and paint directly and quickly with few layers of paint. They want to be able to lift paint easily.

However, when glazing or layering colors, transparency becomes a valuable characteristic because it allows earlier layers to show through. The ability to stain or bond with the fibers of the paper also becomes valuable, because it allows earlier layers to stay put. Not all transparent colors are staining. Paint that stays on the surface of the paper will lift and mix with subsequent layers more easily, which can muddy the work and reduce its luminosity. Test the paints you like to see how they behave. You will find that there is a continuous scale from completely staining to completely nonstaining, and each pigment falls somewhere along that continuum.

Permanence and Convenience

Another important consideration when buying paint is permanence. Permanence is for the future; convenience is for the present. Some colors, especially dyes, can be fugitive. This means that over time they will fade from exposure to light or some component of them will fade so that they change color. This is not a problem with early student experiments but becomes serious when you produce work that needs to last, such as when you start to hang work on your wall, give it away, or sell it. Some paint manufacturers, such as Winsor & Newton and Daniel Smith,

publish data on their paints, and it is important to find out the lightfastness of any paint before you buy.

Convenience colors are worth trying. There is a broad range of browns or earth colors that you can buy, but you can also mix all of them from red, yellow and blue. The particular brown you mix will depend on the proportions of each primary color you use. Using tube greens can also be efficient. Note that some tube greens stain, so you should use them with caution, i.e., mix them with more water, both by pre-wetting the area and on your palette, so that the color can be built up gradually.

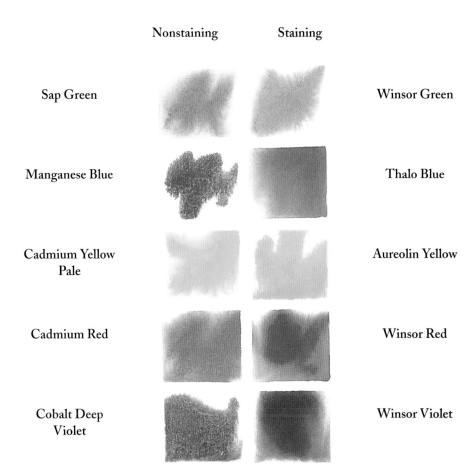

Nonstaining			Staining
Sap Green			Winsor Green
Manganese Blue			Thalo Blue
Cadmium Yellow Pale			Aureolin Yellow
Cadmium Red			Winsor Red
Cobalt Deep Violet			Winsor Violet

NONSTAINING VERSUS STAINING

This chart shows a selection of nonstaining and staining paints. All paints fall somewhere along the spectrum from very easy to lift to very staining, so many don't have either quality to an extreme degree. Thalo Blue is very staining, but Sap Green can vary in its behavior depending on the brand.

Color Choices

Getting to know your tubes of paint is very important. When you test and experiment with the colors you have, you gain knowledge about your colors. Color mistakes often happen because the artist can't predict the consequence of combining paints. Begin by making a complete chart of your paints, then try them out in a variety of experiments. This will teach you what will happen when you layer one particular paint over another, and what a difference more or less water can make.

RECOMMENDED PALETTE

PURPLE-PINK:
Daniel Smith Quinacridone Violet
Winsor & Newton Winsor Violet
Winsor & Newton Permanent Rose

BLUE:
Grumbacher Ultramarine Blue
Grumbacher Thalo Blue

GREEN:
Rembrandt Hooker's Green Deep
Winsor & Newton Winsor Green (Blue Shade)
Rembrandt Sap Green

RED:
Daniel Smith Anthraquinoid Red
Winsor & Newton Winsor Red
Holbein Cadmium Red Orange

YELLOW:
Winsor & Newton Aureolin Yellow
Holbein Indian Yellow

DARKS:
Winsor & Newton Neutral Tint
Winsor & Newton Indigo
Daniel Smith Indanthrone Blue

TRANSPARENT EARTH COLORS:
Rembrandt Transparent Red Oxide
Rembrandt Transparent Brown Oxide
Daniel Smith Quinacridone Gold
Daniel Smith Quinacridone Burnt Scarlet

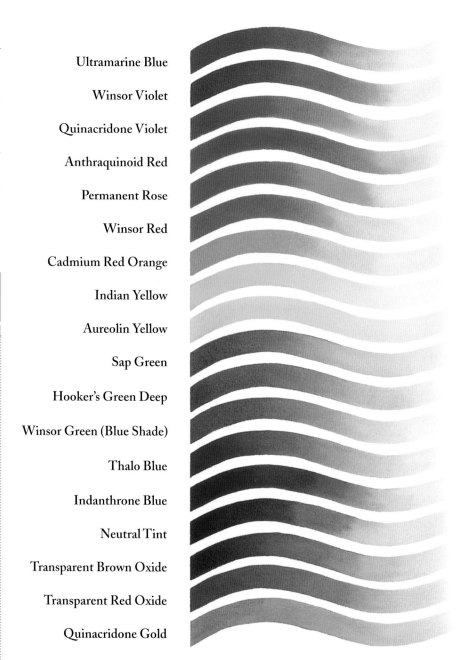

Ultramarine Blue

Winsor Violet

Quinacridone Violet

Anthraquinoid Red

Permanent Rose

Winsor Red

Cadmium Red Orange

Indian Yellow

Aureolin Yellow

Sap Green

Hooker's Green Deep

Winsor Green (Blue Shade)

Thalo Blue

Indanthrone Blue

Neutral Tint

Transparent Brown Oxide

Transparent Red Oxide

Quinacridone Gold

EXERCISE: MAKING PERSONAL COLOR CHARTS

Make a chart of all of your colors, with each one running from its greatest density (directly from the tube) down to almost white (highly diluted with water). Design the chart any way you like—with elaborate shapes or simple squares, arranged in a circle or lined up in rows. Label each swatch with the color name. This chart will serve as a handy reference when you are figuring out which color to use.

These are the colors I use frequently. They are what I call my "working colors" because I use glazes of them to build all my other colors. I also have other colors that I use less often. A complete set of charts for me would be this main one and a series of separate charts for each color family. For example, one chart would have all the yellow paints that I use; another would contain all the blues.

Exercise Your Palette

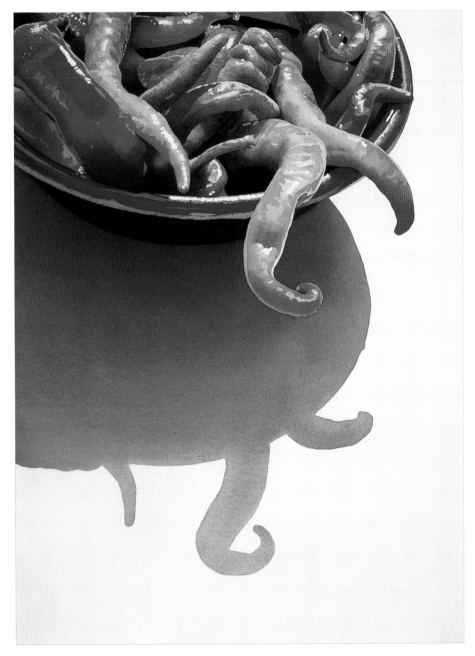

Learn to create a variety of other colors using only red, yellow and blue. Experiment with a warm and cool version of each primary, and see the difference that they can make. Vary the relative strengths of the three colors. Mix a variety of warm and cool grays. Try to make a completely balanced gray and black!

DANCE WITH COLOR THEORY

Pepper Shadows *shows how color theory can be applied to a painting, because it puts into play the side-by-side use of complementary and analogous colors. The dominant red peppers appear more intense placed next to the greens. The blue bowl and cast shadow enhance the vibrancy of the hot orange parts of the pepper. The deep violet in the cast shadow and the pale violet graded wash at the bottom of the painting set off bits of yellow. Within each pepper, the colors are made richer by placing adjacent colors from the color wheel next to each other. The red peppers begin with glazes of Winsor Violet to establish the range of values. When Winsor Red is glazed over this underpainting, a range of reds from deep maroon to brilliant scarlet is established. I leave some areas white in early stages to leave room for white highlights and to glaze Cadmium Red Orange in the warmer areas and Permanent Rose in the cooler parts. Every pepper plays its part in the symphony of colors.*

Pepper Shadows
21" × 13½" (53cm × 34cm)

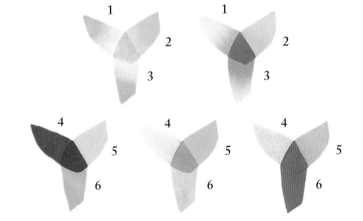

EXPLORE COLOR RELATIONSHIPS

These color triads show you how the primary colors relate to each other. Changing any of the three colors means a different result. Some colors dominate others very easily. There are infinite possibilities.

1. Thalo Blue 2. Aureolin Yellow 3. Permanent Rose 4. Ultramarine Blue 5. Indian Yellow 6. Winsor Red

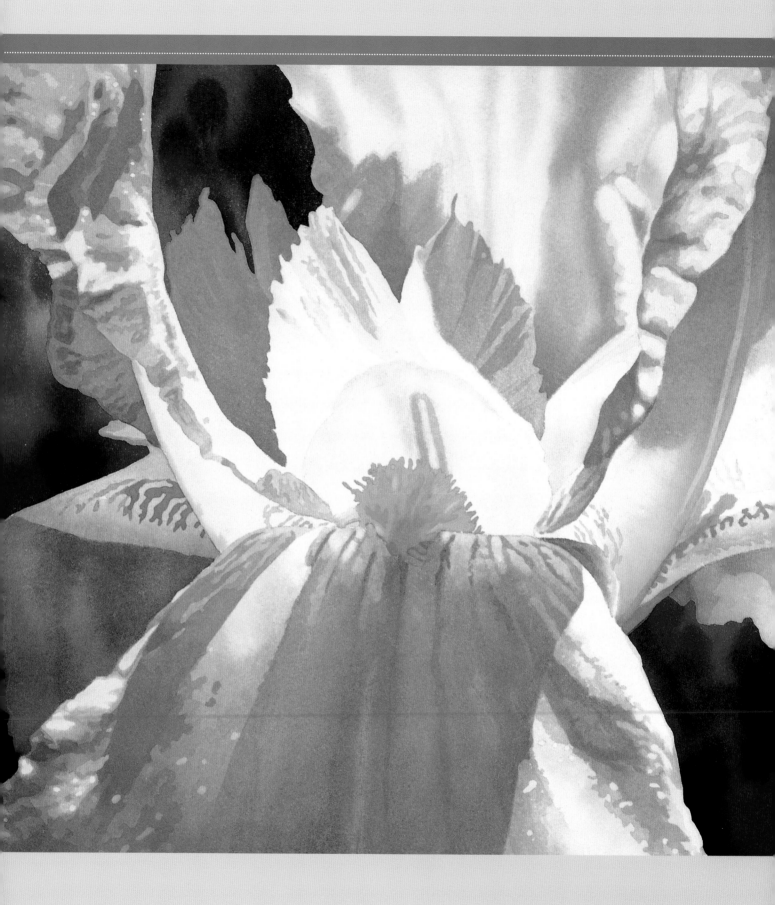

LIGHT & SHADOW: PARTNERS IN THE *Dance*

Make your paintings come alive with light. When you make light the subject of your paintings, you capture the ephemeral moment. The dance of light and shadow creates magic.

The Light Inside
13½" × 21"
(34cm × 53cm)

© E. Kincaid

Light Reveals the World

Light reveals the world. Without light, there is no world. Even at night, you see your surroundings by the traces of light still present. When you paint, you are really painting light, creating the illusion of light. When I seek images to paint, I look for powerful evidence of light—something that will uplift the viewer of my painting in the same way I am uplifted by the object or scene I see. A strong statement about light gives my paintings life. I urge you to seek light, pay attention to it.

Every object in the real world has some unique properties that will affect the way it interacts with light. The ways in which water interacts with light, for example, are numerous. Water is shiny and reflective, also transparent and capable of movement. Wind, gravity and the container transform the shape of water, and when water changes shape, its relationship to the light will change. Artists describe light's interactions in terms of opacity, translucency, transparency and the object's ability to reflect light. Rocks are opaque, completely blocking the light. Glass is transparent and allows both light and images to show through. Petals and leaves are frequently translucent, meaning they let light filter through, but images come through only as simple shapes.

OPACITY BLOCKS LIGHT

The interlocking shapes of light and shadow created by an object blocking the light will reveal its solid weight and form. The opacity of the rock is shown by the fact that it totally hides everything behind it. The dullness of the surface of the rock will be indicated by the lack of shine (lack of hard-edged spots of white or pale blue that reflect the sky). That same light will pass right through the stream to reveal the rocks or mud on the bottom. At the same time, the shiny surface of the stream will reflect the sky and trees overhead.

TRANSPARENCY

A glass full of water is transparent, yet it casts a shadow. The transparency and cut-glass shapes produce a pattern of light shapes in the shadow. The sun was low in this photo, so the shadow is elongated.

MOVING WATER DANCES WITH LIGHT

The interplay of light and shadow brings Great Falls *alive. Sunlight striking from the distant left reveals the facets of the opaque rock. Even though the backlit rocks have shadowed surfaces, the wet surfaces reflect the light bouncing off the water. The appearance of the water constantly changes as this river flows through its channel, turned into clouds and mist by the wind and gravity.*

Great Falls
14½" × 22" (37cm × 56cm)

The light that falls on a rock by a stream also passes through or glances off nearby leaves. Light passing through translucent leaves can make those leaves glow with yellow-green. Light glancing off the top of those same leaves, when seen from above, will reflect the sky or whatever is above the plant and can make it appear pale blue. Relative lack of light (shadow) will add another layer of color and a darker value to the list of possibilities inherent in the image of any leaf.

TRANSLUCENCY

The translucency of the leaves and flower lets light pour through. The white of the paper can make the flower glow as if lit from within, as long as there is enough value contrast with the surrounding shapes. Here the subtle, pale, warm tones of the flower, contrasted by the surrounding darks, makes the white paper glow.

Garden Lantern
14½" × 10½" (37cm × 27cm)

REFLECTIONS

These leaves are translucent enough to play with the shadow and light; you can see the bright sunlight pouring through, and also the shadows cast from the leaves above. However, the tops of the leaves reflects the blue sky overhead. Remember your color wheel? The blue shadows create purple shapes on the red leaves.

Red Storm
21" × 13½" (53cm × 34cm)

Painting the Quality of the Light

The quality of the light and its position relative to any object will influence the image you perceive. For example, bright sun can make everything bathed in its light seem to glow. You can increase the feeling of bright light by increasing the value contrasts so that colors in the light are "bleached out" and colors in the shadows appear intensified. On the other hand, the gray of a cloudy day casts everything into a darker range of values, possibly eliminating the whites in a scene as well as decreasing contrast. Colors appear in more grayed versions of their true selves.

Time of day also has a strong influence on color. Late-day colors are transformed into redder versions of themselves, casting lit-up surfaces into orange or gold variations, and shadows into purple tones. Thus, a bright green tree may become olive green; a gray mountain cast into shadow by a setting sun becomes lavender-gray.

REFINED LIGHT

Translucent and transparent objects glow with the light that seems to fill them. The glass vase dances with the light, refracting and reflecting it.

Daisies in Glass
14½" × 10¾" (37cm × 27cm)

PAINTING SUNSET LIGHT

The sun was setting on this scene, creating a vivid interplay of warm and cool colors. The white granite rock becomes peach and gold in the sunshine and blue and violet in the shadows. The pool of water reflects the deep blue and green of the sky overhead. It's the quality of the light that gives this simple scene its power.

Sunset at Peggy's Cove
14½" × 22" (37cm × 56cm)

Creating the Illusion of Light

Value is the key to creating the illusion of light. Value contrasts establish the existence of light and darkness. Strong sunlight produces strong value contrast between lights and shadows. The soft light of a misty day produces much lower contrast between the darkest darks and the lightest lights. If there isn't much difference in value between the lit and shadowed sides of an object, the painting will lack a feeling of light.

All color has value. To make a light-filled painting, treat color as value. To see value contrast for yourself, place a gray scale next to an image that has a strong feeling of light. Match the values of the lightest and darkest areas of the artwork to determine the contrast range. Your painting communicates strong light when the grays that match your colors are far apart on the gray scale. Your eye can be tricked into misjudging the true values because your perception is altered by the context of the surrounding colors. Use the gray scale as a reality check.

MATCHING TO A GRAY SCALE

Using Ivory Black paint, create a gray scale like the one shown here. Then create a scale using each of your paints, and try to match the tints of color to their corresponding points on the gray scale. A gray scale usually has ten steps grading from 100 % black to 10 % black or 0% black (white). As you can see, most colors at 100% concentration don't have the same value as 100% Ivory Black. Squint to see how closely a color matches its corresponding value of gray. Watercolor paint dries lighter than it appears when wet, so you check the value of each band after it dries. Glaze additional layers until the values match. I painted each color scale separately and then trimmed them and made a collage once I had the correct values.

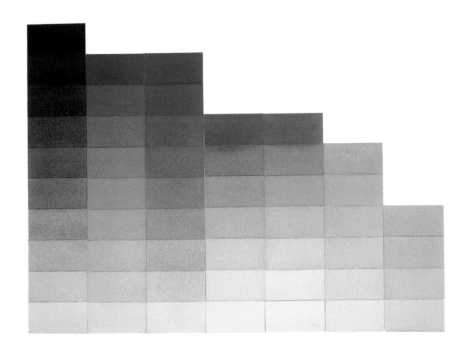

TRANSLATE COLOR INTO VALUE

Choose a photograph and make a painting of it using black paint and water only. You'll have to translate all the colors in their environment full of light and shadow into white, a series of grays, and black. Making this translation helps you to see the value inherent in each color. First, identify the darkest elements and paint them black. Evaluate all other colors for whether they are darker or lighter than their neighbors. This image is split to show how color has value. Use the squint test to match colors to grays.

Made in the Shade
10½" × 14½" (27cm × 37cm)

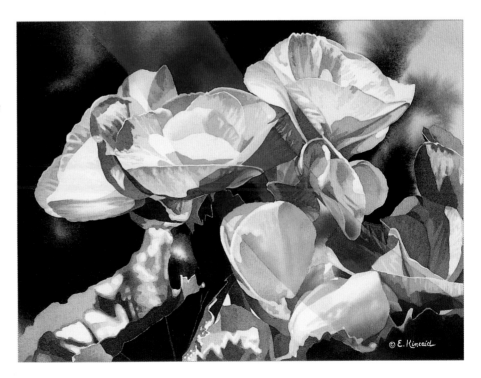

Shadows Reveal Form

Shadows have shape, color, value and sometimes texture. They reveal both form and light. Accurately painting shadows creates the illusion of our three-dimensional world on the flat surface of your paper. Therefore, shadows are an important piece in the design puzzle. They have great power to draw the viewer into the "real" world you have painted and to give force to an image.

Handled badly, shadows can weaken an otherwise strong painting and break the illusion. For this reason, you should seek them out in nature and study them carefully. First, pay attention to where the light is. When the light source is behind or to one side of your subject, the light will create dramatic shadows. When the light is behind you (shining directly on the front of your subject), there will be minimal shadows showing, and the image will seem flat.

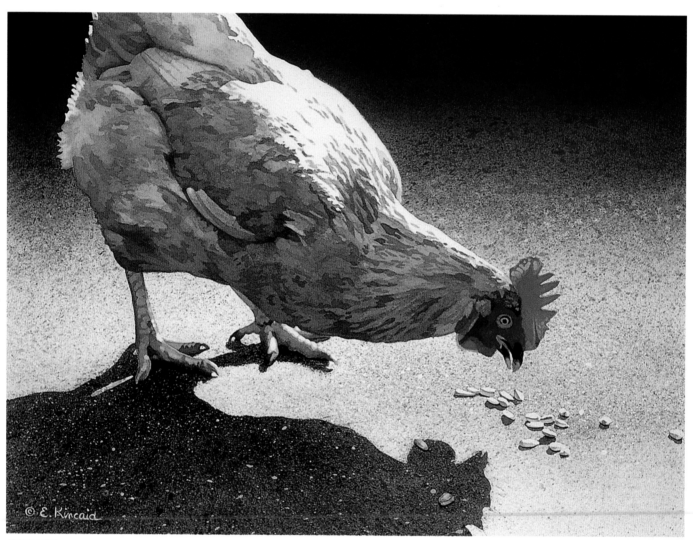

STRUCTURE DESIGN WITH SHADOWS

The cast shadow from the chicken plays an important part in the design structure of the painting. The shadow anchors the composition, and it forms a base for a vertical link between the top and bottom edges of the image. By running the bird's tail off the image at the top and running the shadow off the image at the bottom, I have created a cohesive structure for my idea. The negative shapes of the sunlit surfaces become varied and interesting, and a play is set up between dark against light and light against dark.

Visit From a Neighbor
10¾" × 14½" (27cm × 37cm)

Cast and Core Shadows

There are basically two kinds of shadows. The *core shadow* is found on the side of an object that faces away from the light source. The *cast shadow* is the dark shape on the surface under the object created by the object blocking the light.

The darkest part of the core shadow, the *core dark*, is often at the center of the shadow shape in round objects. The core shadow reveals the three-dimensional form of the object, while the cast shadow says something about both the object and the surface it is cast upon. Both types of shadows tell the viewer something about the time of day and the direction of the light source. The cast shadow will tell you if an object is sitting on a surface or suspended in space. It will tell you if the day is hot and sunny or cold and gray. Light can reflect from the surface onto the shadowed side of the object, so the darkest dark may not be at the base of the object.

Look at your subject and study it! It is important to understand the subtle ways to express all this information if you want to evoke a sense of reality. It is also important to understand this if you want to manipulate these facts about a scene.

Cast Shadow Reflected Light Core Shadow

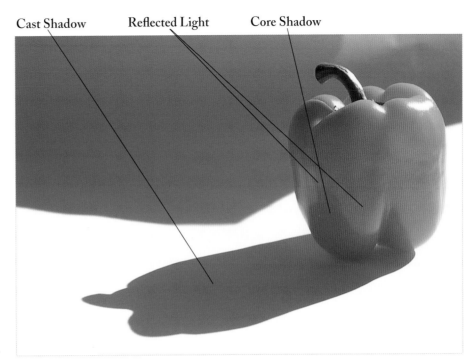

RED PEPPER SHADOWS

Here the pepper is anchored by its cast shadow. Its core shadow gives it solidity. The pepper's shiny surface reflects its white surroundings.

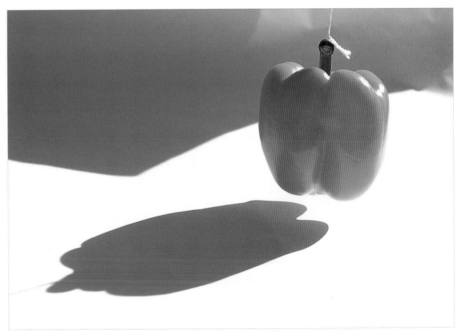

RED PEPPER LOCATION

When the pepper is suspended, it is separated from its cast shadow and the cast shadow changes shape. The cast shadow tells you where in space the pepper is.

Shadow Temperature and Local Color

First, let's consider color temperature. The color temperature of shadows appears opposite to the color temperature of the light that creates them. In other words, on a sunny day, the light is warm and golden, so the shadows appear cool and blue. This is because shadows outside reflect the sky. You see this wherever there is no bright sunlight in the scene to blind you. On a cool, gray day, the shadows can be warm.

Always look for the local color of your subject. The local color is the actual color or hue of anything, minus any outside influence. The local color—both of an object and of the surrounding surfaces—also influences shadow color. The dark side of a red pepper in the sunshine will be a bluer red, and some red will be reflected into any shadow that the pepper casts. If the light source is warm, both shadows will be cool and blued, so the pepper is apt to show a purplish cast in its shadows. If that pepper sits on a brown table, the brown affects the shadows as well.

No formula for color will fit for every situation—you need to see what is really there. The colors of any nearby surfaces, including walls and ceilings, will come into play, so shadows are an opportunity for a rich play of color—a place for the artist to dance.

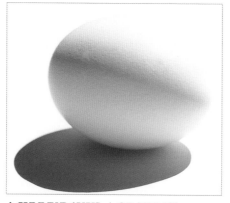 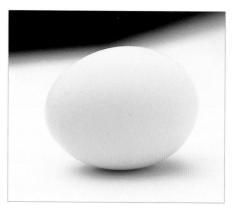

A SUNNY DAY VS. A GRAY DAY

With the bright sun behind the egg, the core shadow appears as a band near the boundary between the lit side and the shadowed side of the egg. Because the egg sits on a white surface, a lot of reflected light from the surface creates a glow in the bottom of the shadow on the egg; notice the golden glow under the egg. The strong sun creates a dark cast shadow, a surprise if you were expecting to see lighter–valued shadows in this all-white scene.

On a gray day, the light is flat and diffused. Without strong light coming from one direction, there is no strong core shadow or cast shadow. There is no blue sky to reflect into the shadow or warm light to bring out the warmth in the egg. All you have is gray and more gray.

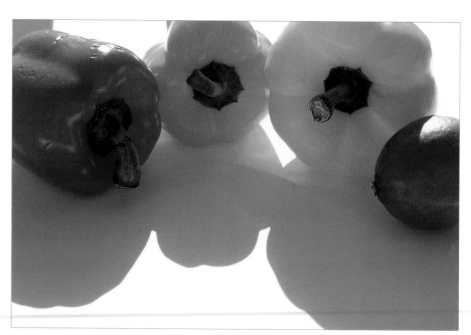

THE PLAY OF COLOR

Each object reflects its own color into the shadow cast onto the white surface. The objects can also reflect their own local color onto each other. The more translucent yellow pepper allows some light to pass through it. In nature, nothing exists in a visual vacuum. The color of each pepper influences the way you perceive the colors of nearby peppers and shadows.

Challenge of Local Color: Yellow

Sometimes the local color of an object will create a special challenge. Let's look at yellow, for instance. Often, artists will use gray for core shadows on yellow subjects, resulting in dull shadows. Another option is to use brown in these situations, but this can leave the area with a heavy quality. Using yellow's complement, violet, is a more luminous choice, but you will still end up with gray or brown shadows.

I find that using the juxtaposition of alternating green and orange areas gives a vibrancy and luminosity to the shadows on yellow objects. These near-complementary colors play off of each other and enhance the richness as well as the lightness of the nearby pure yellow. These colors really shimmer if I have been careful to enhance the intensity of the yellow first, using it at its most saturated state in shadow areas. Any wash over-laying yellow needs to be light or it will overwhelm and hide the much weaker color underneath it.

There is room for a great deal of play in the green and orange color families. The colors can run the gamut from olive green, bright green or blue-green to Red Oxide, Indian Yellow or Cadmium Red Orange. Color does not have to plod; it can waltz.

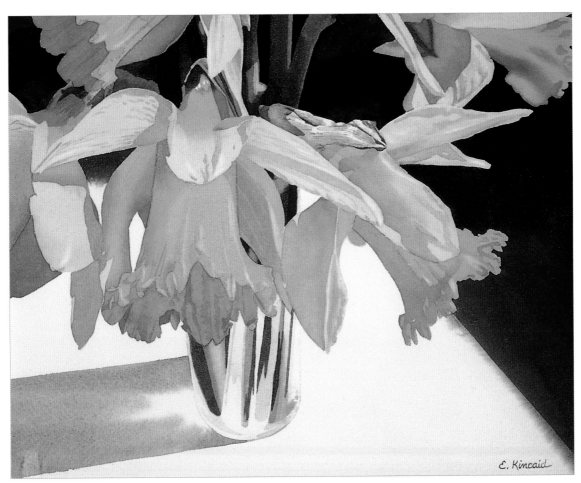

E. Kincaid

DAFFODIL SHADOWS

Home Grown *begins with a diluted glaze of Aureolin Yellow over the whole flower shape. The outer petals are a cooler yellow, so the shadows and texture details in those areas were glazed with additional layers of Aureolin Yellow. The central "bell" of the flower is a more golden yellow, so I glazed those shapes with a diluted wash of Indian Yellow, adding more layers of Indian Yellow for the deeper areas. Where the shadows are cooler, I glazed with very diluted layers of Thalo Blue. Where the shadows appear warmer, I built the Indian Yellow layers up to full strength. Where the warm shadows are a deeper value than the yellow is capable of producing, I glazed Cadmium Red Orange. Some details in the bells of the flowers appear more balanced in color temperature, so glaze Thalo Blue over the Indian Yellow to create a range of olive greens. These areas provide a rich play of color when placed next to oranges, warm grays, golds or sunny yellows.*

Home Grown

10¾" × 14½" (27cm × 37cm)

Give Your Shadows Shape

Now let's consider shape. The core dark and cast shadow shapes reveal the form of the object and the angle of the light source that illuminates it. If the sun is low in the sky, the cast shadows will be oblique and elongated. Objects may even be lit from underneath, such as in a night scene, casting shadows upward.

The shape of a cast shadow tells the angle or point of view of the viewer in relationship to the subject. If you are positioned low, so that the subject is close to your eye level, perspective will distort the cast shadows and cause them to appear compressed vertically; if you are looking down, the cast shadows will be more rounded or closer in shape to the top view of the object itself.

The surface texture of the object or ground where the cast shadow falls also affects the cast shadow's shape. A rough surface like grass or gravel will distort a cast shadow because the shadow conforms to the uneven surface. Flat-sided, angular forms cast angular-shaped shadows. A building will not cast a shadow the same shape as that of an apple. A round apple will not have a rectangular core dark on its shadowed side. In most paintings, there will be situations where cast shadows from different objects run into each other and overlap. When this happens, they merge into one single shape.

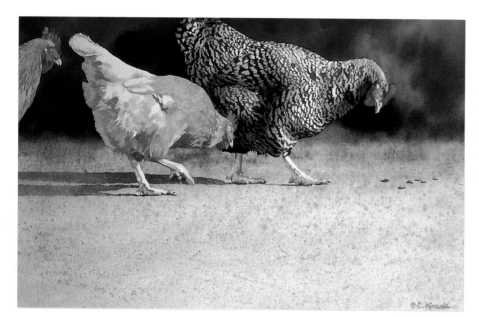

ELONGATED SHADOW SHAPES
With the sun low in the sky and the viewer's eye almost at ground level, the shadows cast by the chickens become long, narrow, horizontal bands connecting the birds to the left edge of the composition. The convoluted core shadows reveal the fat bodies and plump-feathered wings of those well-fed pets. I chose violet for the cast shadow to add life to the gold of the central chicken.

Chickens!
13½" × 21" (34cm × 53cm)

CAST SHADOWS ON AN UNEVEN SURFACE
The shadows cast by this tulip flower and leaves onto the mulch underneath are distorted by the shapes of the bark pieces. The same plant would cast a very differently shaped shadow onto a flat, even surface. The twists and turns of the leaves distort the shadow cast by the tulip. The interaction between the shadows and objects creates an endless variety of shapes. Here, Winsor Violet glazes in the shadows on the ground provide complementary color contrast for the yellow flower.

Golden Boy
14½" × 21" (37cm × 53cm)

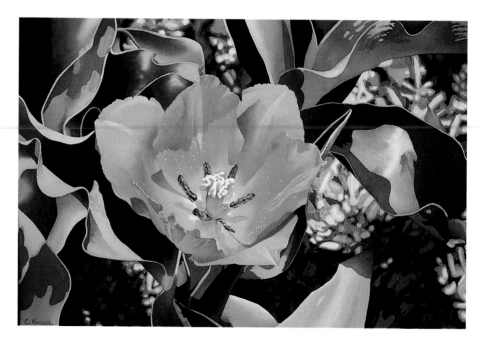

Shadows Are Not Objects

Never treat a shadow like an object. When a shadow is part of a group of overlapping shadows, it will lose its separate edges. Treat the group as one shape. All shadows cast from a single light source have the potential to become one monolithic shape, and when you take advantage of this, you will create stronger paintings.

When there are multiple light sources, which happens frequently in interior scenes, each light source casts a shadow from the object. Where these different shadows overlap, there will be a darker shape. Each shadow will maintain its own edge even when overlapping another shadow. The different shadows can also have different colors, values and quality of edges (hard or soft), depending on the color and intensity of the light. When you handle this complex phenomenon subtly, the result can be a real opportunity for a dance of color. Shadows are an opportunity for expression. Paintings without shadows seem flat and lifeless. Study shadows carefully; be sure you draw them accurately, and never ignore them!

CREATE A STRONG DESIGN WITH MERGED CAST SHADOWS

The red peppers in this painting spill out of the bowl and cast their own shadows on the white tabletop. Even though the peppers and bowl are separate objects, the shadow shape they cast is one single band of color. Because the silver and gold bowl is highly reflective, the shape of the cast shadow is mirrored by the bowl to form a complex, new shape that connects the bowl visually with the surface it sits on. The shadows cast by the nearby doorway link the bowl's cast shadow and the shadowed room behind it to create a single, cohesive and unifying support for the focal point of this painting.

Hot Stuff
14½" × 22" (31cm × 56cm)

TWO LIGHT SOURCES CAUSE TWO CAST SHADOWS

This egg is lit by the sun and a studio light, so you see two separate cast shadows. The sun casts a hard-edged, dark shadow. The studio light is closer and weaker, so it casts a softer-edged, lighter shadow. The studio light is warmer in color than the sun, so its cast shadow is cooler by contrast. The two light sources flood the scene and lighten each other's shadows, except for where the two cast shadows overlap, which is the darkest shadow.

The Value of Shadow

Shadows create a range of values, perhaps the most important contribution they make to a painting. Shadows provide many of the darks necessary for a strong composition. Dark objects and shadows create a pattern of darker values, which can connect the different elements in a painting, giving the piece a cohesive structure.

You can unify your paintings by using a strong pattern of darks and lights. Darks can set off and enhance the impact of the center of interest. Dark values can separate elements so that the shapes are clearer. Shadows anchor objects onto the ground, giving them weight and solidity. Shadows can reveal the strength of the light and what type of day it is. The strong, hot sun of the tropics casts dark, sharp-edged shadows. Cool, cloudy days cast soft-edged, low-contrast shadows.

The value of a given shadow is dominated by the relative value of the local colors present. Value is also influenced by the closeness of the object that is blocking the light. Thus, the cast shadow of a pepper is darker under and closer to the pepper and becomes lighter closer to the edge. A shadow's edges are influenced by how close the light source is. Light that is close to an object will produce soft edges; when the source is far away, those edges are sharper.

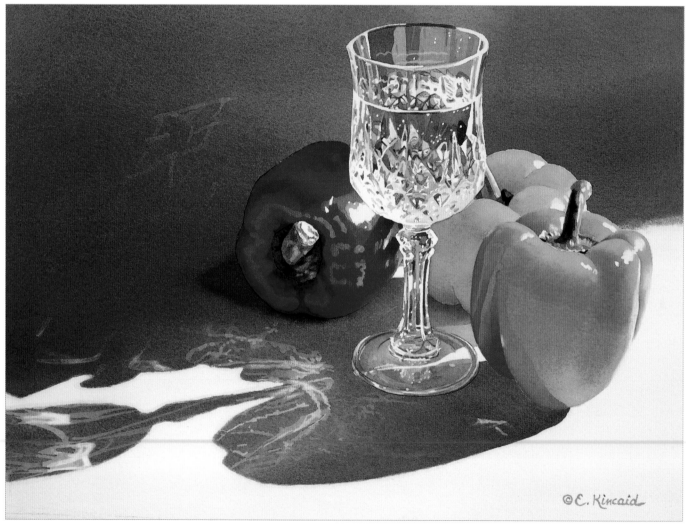

PLAY WITH LIGHT AND SHADOW

These peppers and cut crystal glass sit on a sheet of white paper that has been bent up to form a seamless backdrop. The reds and oranges of the peppers influence the shadow's color near them, and the values are deepest under the red pepper. Refracted color plays along the cut crystal, splicing together the shattered reds and yellows of the peppers with the purples and blues of the shadow. The crystal also throws out delicate threads of white light, visible only against the coolness of the deep shadow. The facets of the glass splinter the light, filling the cast shadow with playful shapes.

Splintered Light
10" × 14" (25cm × 36cm)

The Transparency of Shadow

Shadows are not solid objects! Although this seems obvious, the appearance of solidity in shadows is a common problem in paintings. Photographs often make shadows appear opaque. The key is to show the transparency of shadows, even and especially when the shadows are dark. Creating the appearance of transparency may seem like a challenge, but the solution lies in texture and detail. Any lines, shapes or broken surfaces that appear in the surrounding area need to be enhanced where the shadow passes over them, not obliterated by the wash, as often happens with dark shadows. You need to darken those areas to compensate. Sometimes you may need to soften the edges of a shadow, even though it may appear sharp-edged to the eye, in order to enhance the illusion. You need to make it clear that the shadow shape is not just another object in the picture.

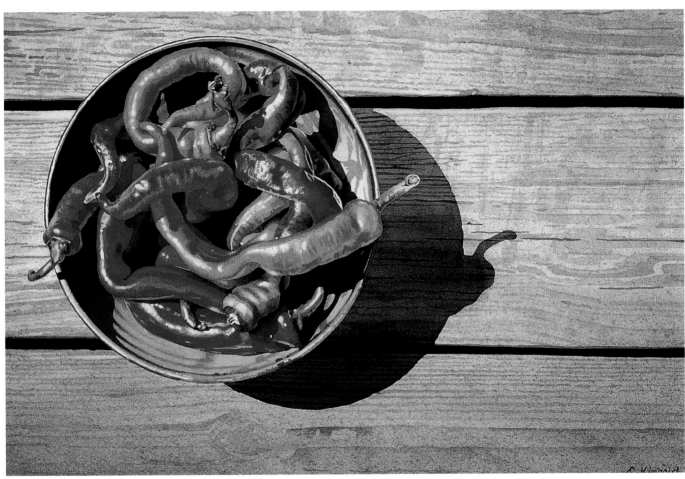

SEE-THROUGH SHADOWS

The details are painted with diluted color where the light falls. The grain of the wood and dark gaps between the boards don't disappear under the shadow cast by this blue bowl filled with cayenne peppers. To enhance the effect of strong light and transparent shadows, I intensified the contrast within the cast shadow with stronger glazes of Ultramarine Blue and Transparent Brown Oxide on the grain lines. The concentric rings formed by the molding on the bowl and the pattern of blue ceramic glazes distort the shape of the deep shadow within the bowl and create a visible pattern in the lighter shadows cast by the peppers.

United Confederation of Peppers
14½" × 22" (37cm × 56cm)

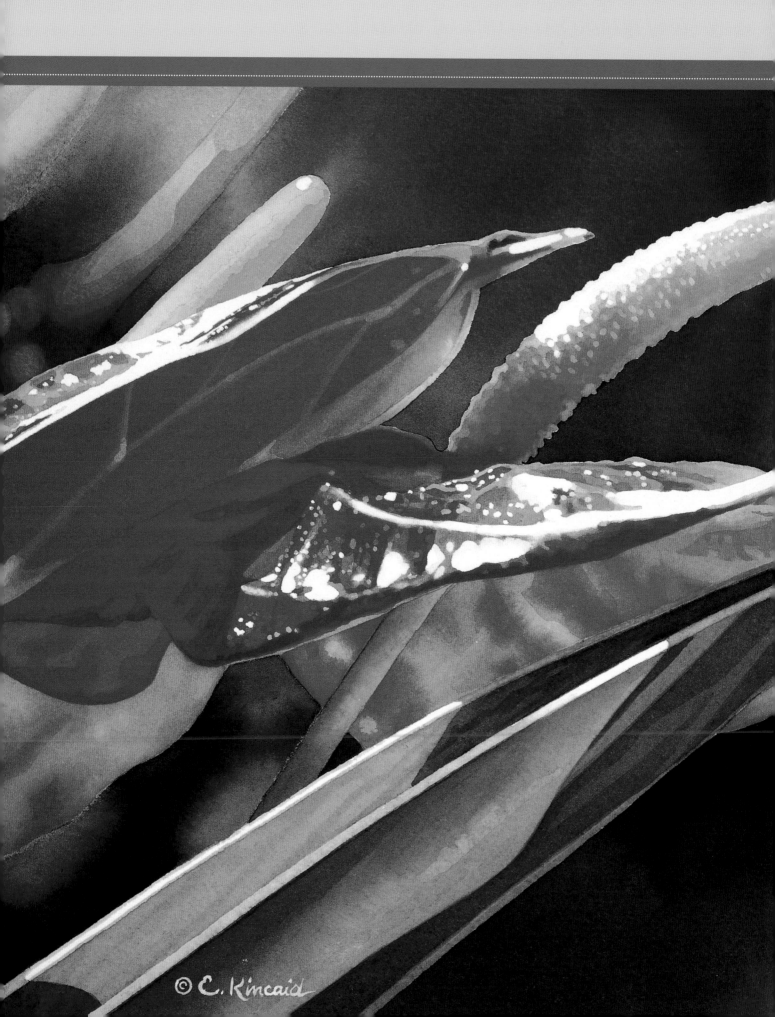

© C. Kincaid

THE WHOLE
Dance

I chose this image because of the strength and boldness of the brilliant flowers against the dark background. Each step in the building of this painting demonstrates the application of principles and techniques detailed in the earlier chapters of this book. Follow the steps to see how this painting came to life.

Unexpected Gift
10½" × 14½"
(27cm × 37cm)

Unexpected Gift

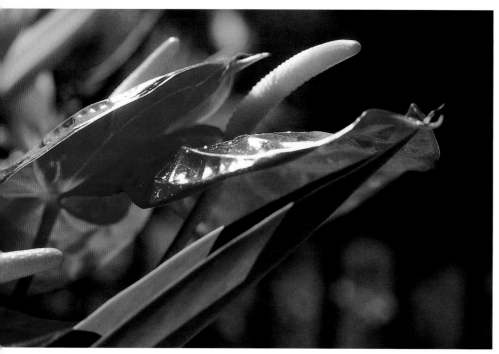

REFERENCE PHOTO
This painting begins with a slide of flowers backlit by the sun.

To bring out the light and fire in these anthuriums, create a background that is cool and dark. The impact of this image comes from the fiery colors and the strong diagonal thrust of the shapes. The challenge is to design a background that provides contrast for the color and a "brake" for the movement of the shapes.

MATERIALS LIST

BRUSHES
¼-inch (6mm) flat scrubber
1-inch (25mm) flat wash brush
1½-inch (38mm) flat wash brush
2-inch (51mm) flat wash brush
nos. 1-14 round brushes

MASKING MATERIALS
colorless liquid Frisket
drafting tape
Frisket Film
Gator board
no. 2 pencil
permanent waterproof fine-tip marker
scissors
small sharpened paintbrush handle
sketching paper
white artist's tape

PAPER
Arches 300-lb. (640gsm) cold-pressed
 watercolor paper

PALETTE
Anthraquinoid Red
Aureolin Yellow
Cadmium Red Orange
Hooker's Green Deep
Indian Yellow
Neutral Tint
Permanent Rose
Quinacridone Burnt Scarlet
Quinacridone Violet
Thalo Blue
Transparent Red Oxide
Ultramarine Blue
Winsor Red
Winsor Violet

VALUE STUDY
Your first step is to draw a thumbnail sketch. The goal is to increase the clarity and impact of the image. One way to achieve this is to crop off the left side of the image, add some space to the right side and simplify the background. Move the big leaf up toward the upper right in order to separate its tip from the flower's tip. Make sure the value statement is strong.

DRAW THE DESIGN

1 Once the design is decided, do a clean line drawing on the watercolor paper with a basic no. 2 pencil. I have drawn darker lines here for you to see, but for painting, the lines should be as light as possible. Draw all of the shapes you see, not just the shapes of objects. To make the paper easier to handle while painting, tape it to the Gator board using the white artist's tape.

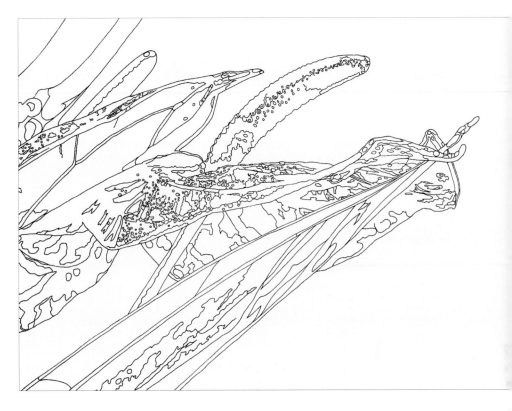

PROTECT THE FOREGROUND SHAPE

2 Trace the area you'll be masking—the massed shape of the pair of flowers and the leaf—onto the masking film with a permanent fine-tip marker, drawing about ¹⁄₁₆ inch (2mm) inside the lines and have the film lap over onto the taped edge. Cut the masking film, then peel the backing paper off and lay the film down.

SEAL IN THE FOREGROUND SHAPES AND BEGIN TO PAINT

3 Completely seal the edges of the masking film with masking fluid. If the shape runs off the paper and over the tape, you can seal that edge with tape (which is quicker but less airtight than masking fluid). After carefully sealing the masking film, let everything dry. Using a 2-inch (51mm) flat, begin each wash by wetting down the whole surface—except the upper-left corner where the blue and yellow flower shapes will go—with clear water. Use a no. 14 round loaded with highly saturated Aureolin Yellow to make loose strokes on the wet paper wherever the background will be green or yellow.

HARMONIOUS BACKGROUND

Watercolor is a dynamic medium and you can increase the action by painting on a sloping surface. Different stages of the process will require the help of gravity, so being able to turn and tilt the painting is essential. After painting each wash, use a tissue to wipe up any excess liquid from around the edges. Allow everything to dry completely (a "juicy wash" may take up to three hours to dry).

MAKE IT SING!

4 Turn the painting upside down. Coat it with water again, but use a light touch to minimize lifting the yellow layer. With a no. 10 round, paint a strong layer (meaning paint with only a small amount of water) of Winsor Violet into what is now the lower left. The purpose of this stroke is to introduce variation and liveliness into an otherwise simple, dark area. The violet will add to the intensity of the yellows in the flower by providing complementary color contrast. The shape of the violet area also acts as a brake for the strong movement of the flowers and leaf. Paint the darkest shapes of the blue flower in what is now the lower-right corner; use Ultramarine Blue with a no. 2 round. Use the no. 2 round to glaze the adjacent corner with Indian Yellow, then let everything dry.

GO WILD AND PLAY!

5 Turn the painting right side up and wet the largest shape again. Also wet the corner shape to the left of the blue flower. Then, with a no. 5 round, paint a graded wash in that small shape with strong Thalo Blue. Use a 1½-inch (38mm) flat and an equally saturated Thalo Blue to paint the areas where the greens will later be in the large shape and beyond the borders of the Aureolin Yellow. Turn the brush as you paint, creating different strokes. Use the brush to cover a large area with one smooth stroke and then turn it to create a delicate calligraphic stroke as part of the same continuous movement.

GIVE THE PAINTING BLUE

6 Turn the painting upside down. Tilt the board so the entire painting slopes down to the lower left. Wet the large area of paper to the left of the blue flower. Glaze a layer of strong Ultramarine Blue on the left side using a 2-inch (51mm) flat and painting around the greens and violet. While the paper is still wet, reinforce the violet with another glaze of Winsor Violet using the no. 10. If the colors don't appear strong enough when the paint is dry, repeat this step. Allow all this to dry, then glaze Thalo Blue between the blue flower and the yellow flower in the lower right corner.

Turn the painting right side up again, and re-wet the same large area. Rinse your brush often as you wet the paper at this stage; the heavy buildup of paint will lift easily and can then travel. Glaze a strong layer of Thalo Blue along the bottom with the 1½-inch (38mm) flat. Use diluted Thalo Blue to glaze the top of the painting.

GO TO BLACK AND BUILD THE CORNER

7 Turn the painting on its side so the yellow and blue flowers are in the upper-right corner. Wet the large area of the painting again. Then, using a 1-inch (25mm) flat, glaze Neutral Tint in a waving band from under the flowers to what is now the bottom edge. Wipe up any excess, and allow everything to dry. The Neutral Tint glaze takes the already dark area all the way to black.

Next, add a series of wet-into-wet glazes to the yellow flower in the upper-right corner. The colors should be warm, orangey hues: Cadmium Red Orange, Transparent Red Oxide, and Quinacridone Burnt Scarlet. Apply these with a no. 2 round, and allow each layer to dry between applications.

Before glazing onto the dry paper of the blue flower shape, make sure the area next to it is completely dry. Begin with the darkest shapes, painting them Ultramarine Blue with a no. 2 round (let dry between layers). Each shape painted should be larger and lighter and should contain the earlier shapes. When all this is dry, glaze over the blue flower and into the background with diluted Thalo Blue; this will tie the areas together. While this wash is still wet, add a very strong Thalo Blue or Ultramarine Blue where needed for the darkest areas.

PAINT THE LOW NOTE AND BEGIN THE NEXT STAGE

At this point, step back from the painting and evaluate the values, colors and shapes. Imagine the flowers in their space. Is the contrast going to be strong enough? Is there a connection between the foreground and the background? This stage in the painting process is the point of transition between loose creation of the background and beginning to create the illusion of real flowers.

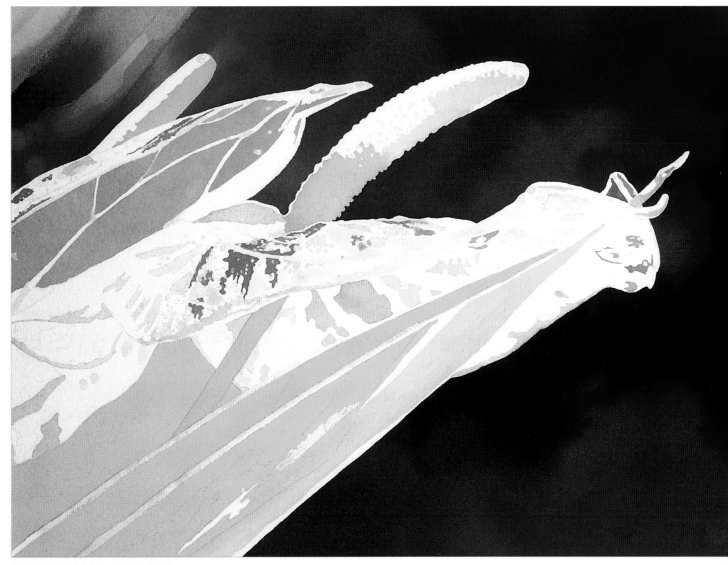

START SMALL, END BIG

8 Turn the painting right side up. Remove the masking film. You'll need to smooth any rough edges left behind. Use a no. 1 round to paint dips in the edge to match the the background colors. To pick up paint that bled under the masking fluid, first lay down a piece of drafting tape to protect the sharp edge and background. Then lift the unwanted paint with a ¼-inch (6mm) scrubber, water and a tissue (see chapter nine). Apply masking fluid to any small spots that will be white or that will be lighter than or different in color from the surrounding areas. Let the masking fluid dry.

Starting at the top, use a range of round brushes from no. 3 to no. 7 to glaze the first layers for each area. Paint the smallest and darkest shapes first, such as the pattern of dark shapes created by light falling on the convoluted tops of the red and pink flowers. Skip around so that you don't paint any shape while its neighboring shape is still wet. Paint the columns and stem with Indian Yellow. Paint the flowers with Winsor Red, Permanent Rose and Winsor Violet. Paint the leaf and the background shape between the stems with concentrated Aureolin Yellow. The outer part of the leaf has parts that are less warm, so dilute the Aureolin Yellow there and leave some areas white. Part of the leaf edges are lighter, and those spots have been protected with masking fluid as part of the first step in working on the flowers and leaf, as mentioned above. Paint the yellow around the entire edge of the leaf.

LARGE SHAPES, SMALL SPACES

Paint wet-into-wet for large or soft-edged shapes. Paint on dry paper for small shapes with sharper edges.

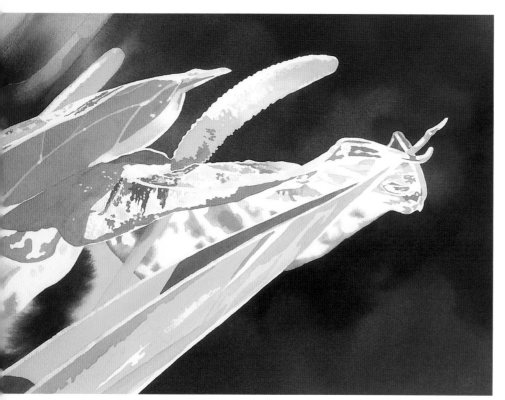

BUILD ON YOUR FOUNDATION

9 Glaze a second layer on every area that needs more color, starting at the top. The columns of the flowers need Aureolin Yellow. Often, each glaze will be larger and more diluted than the one before. As the washes get larger, switch to larger round brushes. Where shapes need to be soft edged, wet the area first and then paint wet-into-wet. Glaze the section of background and leaf with Thalo Blue. Glaze the top edge of the stem with Winsor Red wet-into-wet.

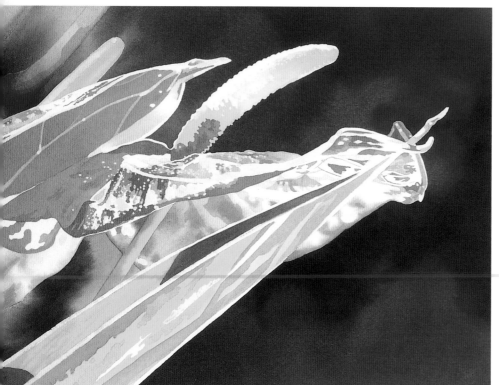

THE THIRD GLAZE

10 In some areas, the darkest spots need reinforcing as you lay larger washes over them, such as the violet shapes in the shadowed part of the red flower or the Permanent Rose areas on the pink flower. In other areas, it is time to paint large washes with larger brushes. Glaze Quinacridone Violet using a no. 5 round on the pink flower's darkest shapes that already have a layer of Permanent Rose. Begin glazing the larger column with Winsor Red, using uneven sideways strokes to imply the bumpy texture. Paint wet-into-wet for large or soft-edged shapes. Paint on dry paper for small shapes. Use no. 3 through no. 8 round brushes. Paint the light pattern on the inner leaf in Thalo Blue with the tip of a no. 5 brush on wet paper. Paint the pattern on the outer leaf on dry paper with the same brush and color, but with the Thalo Blue more diluted.

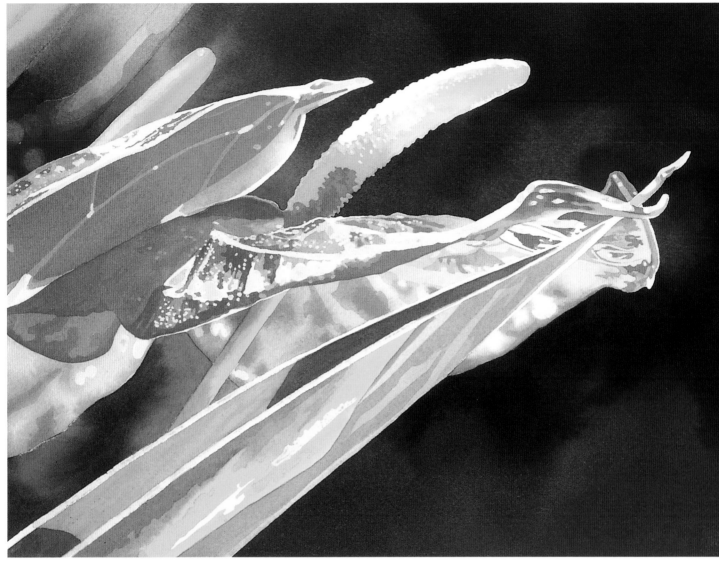

GLAZE, AND GLAZE AGAIN

11 With a no. 2 round, glaze the darkest part of the blue flower with Winsor Violet. Using a no. 5 round for both, glaze the smaller column with Cadmium Red Orange and the larger column with Permanent Rose. Use a no. 10 round to glaze most of the underside of the pink flower with Permanent Rose. Glaze the red flower with Winsor Red and Permanent Rose, then use Cadmium Red Orange to glaze the warmer red areas and the stem. Both the inner leaf and the bottom of the outer leaf need a layer of Hooker's Green Deep. Glaze the section of the background and the upper edge of the outer leaf with Thalo Blue. Wait for the paint to dry and then begin removing masking fluid where the color is built up enough, such as the underside of the pink flower, the light spots in the shadowed part of the red flower, the underside of the flower, and also the tip of the red flower. Remove the masking fluid first from the spots that will end up with the deepest color when the painting is completed.

Continue glazing. Put masking fluid on top of any colors you'd like to preserve on the larger column, like light orange, pink and yellow spots. Glaze Quinacridone Violet on the pink flower and on the darkest spots on the red flower. Continue with all of the colors, removing masking fluid as surrounding areas reach the right intensity. These newly uncovered spots will be lighter when the painting is finished.

MAKE THE FLOWERS HOT!

The goal here is to build heat and light. Watercolor tends to dry lighter and duller than it appears when wet, so repeat glazes until you get the color you want. These flowers get some of their heat from the play of relatively warm and cool versions of the hot colors next to each other. The cool pink flower touches the fiery red flower. The red flower ranges from relatively cool Permanent Rose to warm Cadmium Red Orange. The yellow-to-red play of the columns rises above, and all of the complementary pairs add punch.

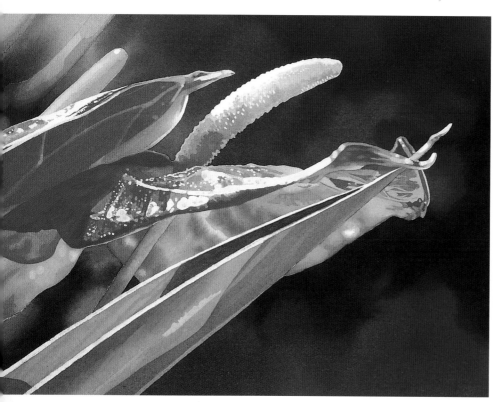

GO DEEPER

12 Glaze the larger column with layers of Winsor Red and Cadmium Red Orange. For the dark red areas on the top side of the red flower and on its right end, use Anthraquinoid Red. Continue to remove masking fluid from lighter spots like the tip of the pink flower's column and the lightest spots on the underside of the pink flower and the tip of the red flower. Glaze again. Remove the masking fluid from the lightest spot on the outer leaf. Use a no. 10 round to glaze the whole outer leaf with Hooker's Green Deep. Paint the tip of the larger column with diluted Hooker's Green Deep, using a no. 3 round. Glaze the stem with Thalo Blue wet-into-wet. Add Cadmium Red Orange to the tip of the pink flower. Glaze the isolated shape of the background and the outer leaf with Thalo Blue again. Glaze the red flower's underside with Cadmium Red Orange, Winsor Red, Permanent Rose and Winsor Violet. Glaze the extreme tip of the leaf with Cadmium Red Orange.

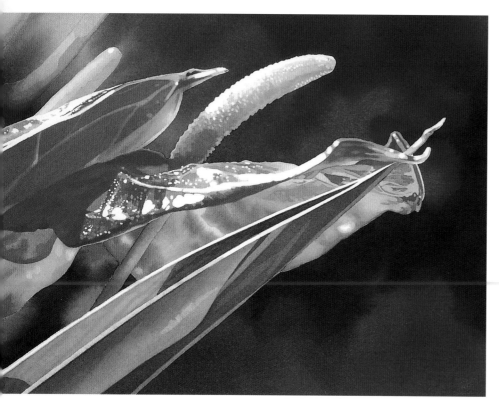

SHRINKING WHITE PAPER

13 At this point, remove most of the remaining masking fluid. Glaze the larger areas that need deeper color. During this step, decide where you want the whites to be. You've preserved some white paper with masking fluid, but now you could quiet some of those white areas with diluted glazes. The white of the paper should remain rare and very important, giving the painting a sparkling quality.

Glaze until every area works in relation to every other area. Remove the masking fluid from the leaf edges, and clean any rough edges of the leaf using drafting tape, scrubber brush, water and tissue. Glaze the left end of the whole leaf with Aureolin Yellow, feathering out the color so it doesn't leave an abrupt edge.

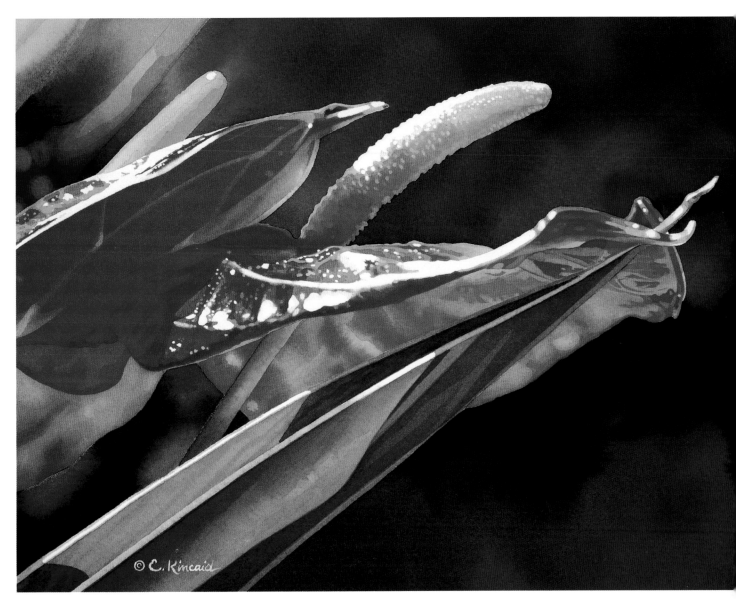

IS IT DONE YET?

14 Step back. How is the painting working? Are the values right? Do the colors sing? Continue glazing until you're satisfied. Remove the last of the masking fluid from the larger column. Glaze the base of the column with Quinacridone Violet, the underside with Cadmium Red Orange and the tip with Indian Yellow. Paint the leaf edges with Indian Yellow and then Quinacridone Burnt Scarlet. Using the scrubber brush, soften any edges that are too hard and lift out lights that have gotten too dark, such as the light spots on the tops of the flowers and columns and the lit-up edges of the leaf. Glaze the section of background again and the tip of the column with Thalo Blue.

Unexpected Gift
10½" × 14½" (27cm × 37cm)

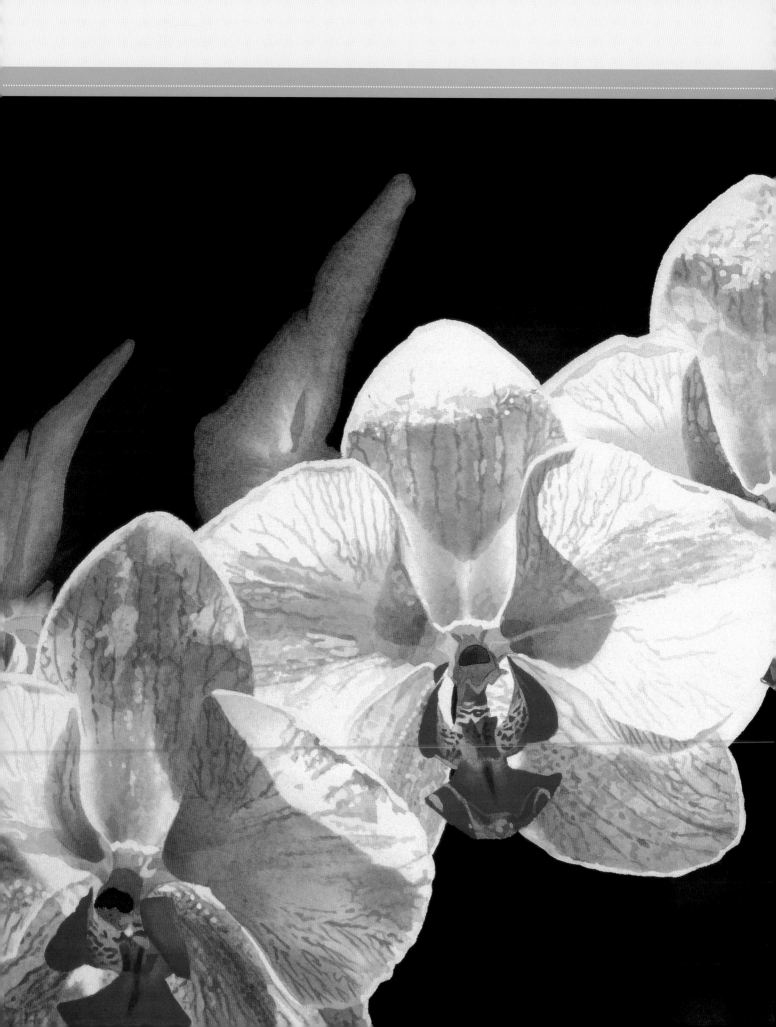

EVALUATING THE
Result

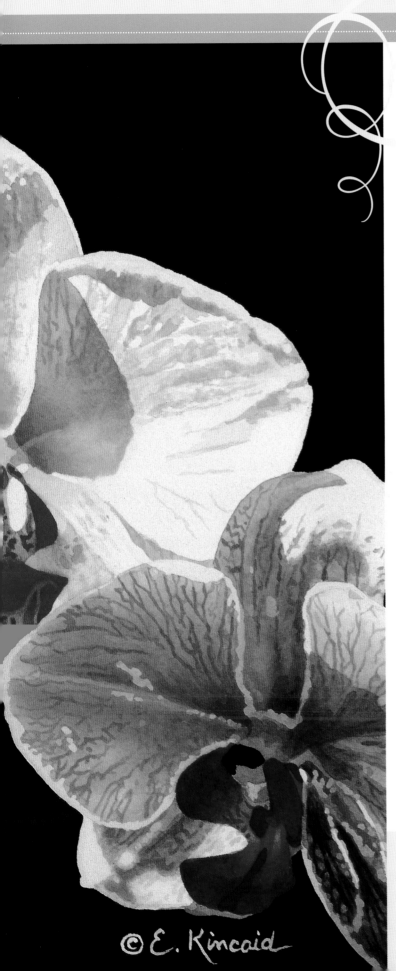

Let the painting speak to you. Painting is a duet. In the beginning, I have an intention for each painting. There is the reference photo to guide me and a thumbnail design. However, there comes a point when I need to stop being the singer and just listen to the song.

I am drawn to paint something because of a feeling. The work is finished when I experience that same feeling again while looking at the painting.

Orchid Arch
10½" × 14½"
(27cm × 37cm)

© E. Kincaid

Are We There Yet?

Deciding when a painting is finished is a major hurdle for every artist. That ability to decide is frequently the final boundary between the student and the accomplished artist. The question I am asked the most is "Is my painting done?" In struggling with this, artists run the gamut between stopping too soon and overworking something that was once fresh and beautiful. You need to learn to recognize when a painting is in trouble, and then how to salvage something that is in trouble. These questions ultimately have to be answered by each artist individually, but there are some guidelines that may help.

To answer these questions for yourself, you need to learn how to evaluate your paintings with fresh eyes. That means stepping back and starting over, as if you have never seen the painting before. Go back to your thumbnail drawing. Do the value relationships in the painting correspond to those you created in the thumbnail? If they do, is that still a good idea? Does the design work as well with the details and colors in place? What path does your eye take through the painting? What attracts you? If the painting doesn't match the original thumbnail, make a new thumbnail of the existing painting. Does this new design work when you reduce it to values alone?

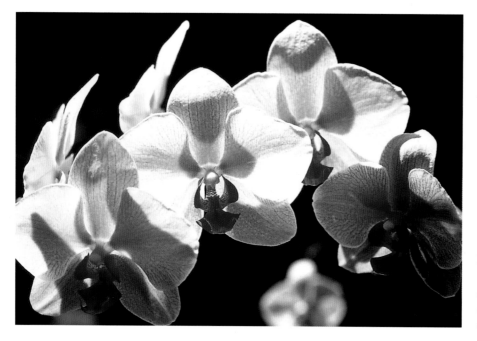

REFERENCE PHOTO
The photograph for Orchid Arch *attracted me because the white petals seem to glow with their own light and the arching shape of the cluster makes the flowers seem to almost take flight.*

Does Anything Bother Me?

One question I hold in mind when studying a nearly completed painting is "Does anything bother me?" I keep painting and asking that question over and over again until the answer is no. The more you learn, the easier it is to make these decisions.

So the question "Is there a problem?" has been asked, and the answer is yes. What next? There are three options: add, subtract or both. These solutions apply to every problem.

THUMBNAIL
In the thumbnail, I checked to see that the negative shape of the background created by the massed shapes of the flowers is interesting. I eliminated everything that took away from my essential idea.

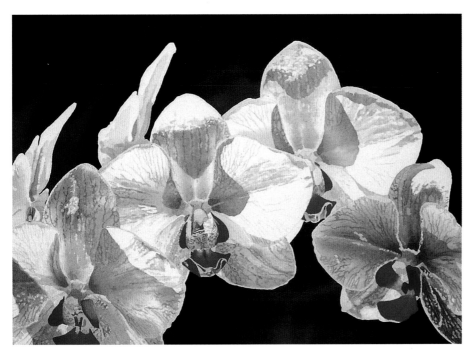

TAKING THE PAINTING FURTHER

Up to this point, I developed the painting to reflect the information in the reference photo. In the final stages, the painting needs to go beyond what the reference happened to show. The painting has to speak for itself.

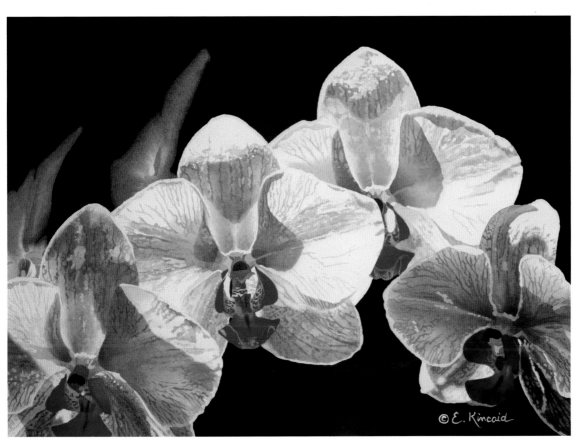

THE OUTCOME

I decided that the two petals sticking up were a distraction from the strong arching movement of the painting, so I softened their edges and then glazed them with Winsor Violet to push them back and quiet them down. I washed the glaze right over into the background to further soften the edges and subdue the impact of the vertical petals.

Orchid Arch
10½" × 14½"
(27cm × 37cm)

Does It Clearly Express a Good Idea?

What makes a painting both complete and successful? First and most importantly, it needs to make an impact. It needs to say something. It should tell only one story. The design should be strong and clear. The values should work together to support your idea. The colors should be clear and appropriate to the idea. The drawing needs to be either accurate or stylized in a consistent way. The presence or absence of detail and texture in any particular section of the painting should be appropriate to the idea. Notice how it always comes down to the idea? A painting is successful when it clearly expresses a good idea, and it is finished when there are no barriers left to seeing the idea.

THUMBNAIL

I was caught by the idea of a fresh look at a common thing. Dahlias grow close to the ground, but if you lie on the ground and look up, you see them in a whole different light. A simple idea, really. The challenge was to clear away anything that might distract attention from the core idea.

FOCUSING ON THE FLOWER

I glazed Winsor Violet and Thalo Blue first to establish a cool background for the warm yellow flowers. Since cool colors recede and warm colors come forward, a cool background won't compete with the flowers for attention. The cool background also increases the sun-filled quality of the flower due to the temperature contrast. In order to gray the background while still emphasizing the clear color of the flower, I glazed diluted Indanthrone Blue, which is a blue-black. All the brilliant color was reserved for the large flower. I began the flowers with spots of masking fluid and a glaze of Aureolin Yellow.

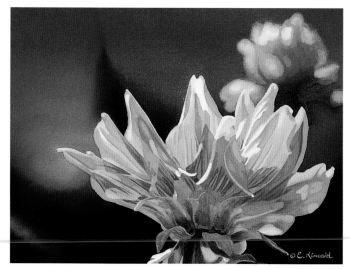

TONING DOWN THE DISTANT FLOWER

The background flower started out more prominent and had hard edges from being masked. At the end, I softened the edges and glazed the flower with Thalo Blue so that it moved back and doesn't compete with the main flower.

The Dahlia Is Out
10½" × 14½" (27cm × 37cm)

Take A Few Steps Back

When your painting is nearly done, get some distance from it, both with your feet and with time. This is the third place in the whole process where you need to use fresh, unprogrammed eyes. Now you need detachment. Prop the work up where you can get far away from it, and then leave it there for a while. Go about your business, maybe even start your next project, glancing over at the painting from time to time. Every so often, spend some time just contemplating it from a distance.

Turn the painting upside down. Getting some distance helps you disconnect yourself from the habit of seeing what you expect to see. The subject becomes just a set of shapes. Every painting has to work well as an abstract design before it can hope to work well as a representational painting. Turning the painting upside down also helps if you are trying to see if an image that is supposed to recede really has the depth you think it has. The "ground" at the bottom of the painting should seem to loom overhead. Another trick is to prop the painting up in front of a mirror and then study the reversed image you see there. The reversal can jolt your attention out of its complacency—suddenly you see the painting for the first time. Even though you have to be right on top of something to paint it, you should ask and answer these questions from a distance. Otherwise, you're apt to nitpick the thing to death.

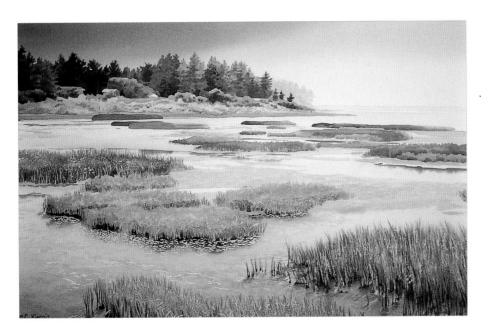

HOW IT LOOKS
From this angle, the painting looks fine, but how many times have I seen it? How many hours have I spent looking at it? Would I even notice any flaws it might have?

Big Lagoon
13½" × 21" (34cm × 53cm)

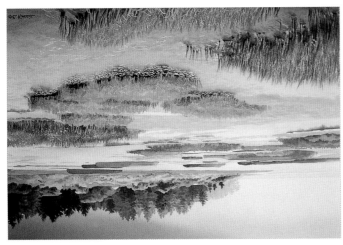

UPSIDE DOWN
Look at Big Lagoon *upside down, and the original foreground seems to loom overhead like a ceiling. This is a good test for whether a painting shows a strong sense of deep space. When I see a painting this way, I see a new image.*

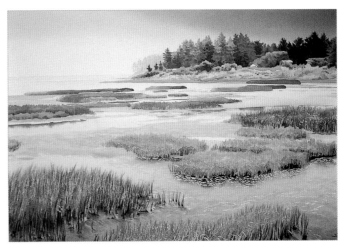

MIRROR IMAGE
The mirror image changes the feeling again. Use techniques like these to help you see a painting you have been working on as if for the first time.

Strengthen the Color

What if the problem is that the color is wrong? The solution is usually to add glazes. You may need to lift some color first if the paint is too intense or too heavily applied for a glaze to work. Building a painting from glazes is a huge advantage in that regard; you are less apt to create areas that are too heavy. You can lift staining pigments with a scrubber brush (or toothbrush) and water, then blot with tissues. Other pigments can be lifted more gently by soaking with a brush, scrubbing with a natural sponge and blotting.

How do you decide what color to use in a corrective glaze? First determine whether it needs to go warm or cool. Basically, some variety of yellow or red will warm an area, and blue will cool it. If you have a problem with an area that has turned to mud, it's best to stick with primary colors. At this late stage, more-complex neutral colors are apt to dull or muddy the situation even further. Grayness results from the three primary components being too balanced, so throw things out of balance toward the warm or cool end. If you need to change an area but want to keep its brightness, look to either side of that color on the color wheel. You can choose any of the colors to the left or right of your original color, but stop before you reach a color that has any of your original color's complement in it.

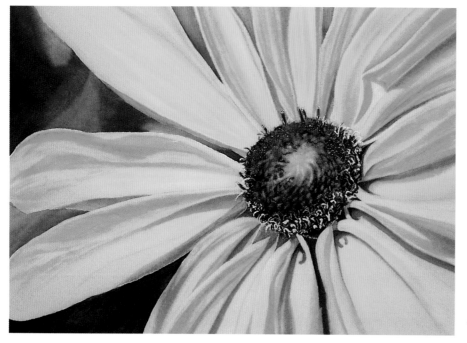

THE PROBLEM

In my student Cheri's painting of a black-eyed Susan, the colors Aureolin Yellow, Indian Yellow, Cadmium Yellow Medium, Thio Violet and Prussian Blue are well established but lack the intensity they could have. The center is beautiful but is not yet an accurate representation of this flower. The shapes in the background are competing too much with the center of interest.

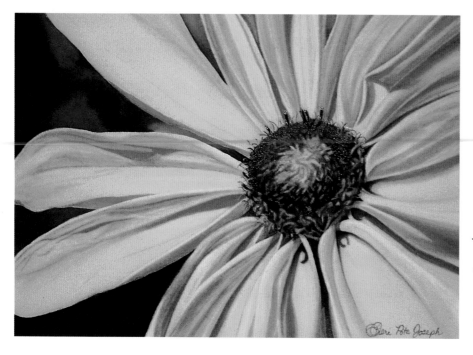

THE SOLUTION

The answer is to glaze the petals with more of the same yellows and violet to build their intensity of color and to lift lights from some petals' edges with a scrubber brush. This increases the contrast and sense of light in the painting. The center also benefits from lifting with a scrubber, followed by glazes of yellow to reestablish warmth. Glazing the background with Prussian Blue subdues the shapes and increases the impact of the brilliant gold flower.

Susun
Cheri Joseph
10" × 14" (25cm × 36cm)

Manipulate the Value Contrast

Frequently, a painting's trouble is in its values. Maybe the values hide an otherwise clear pattern and design. Maybe the contrast isn't right for the spatial relationships. The first possibility is a design problem, and the second is a problem with the illusion of space. High contrast between adjoining shapes will both draw the eye and make one shape come forward, while low contrast creates the opposite effect. Manipulating these relationships is the key to making effective paintings. Lifting to lighten and glazing to darken are obvious solutions to these problems once you have decided where you want to direct the eye and what you want to advance or recede. Often, the problem has been created by indecisiveness. Sometimes, making any decision and then sticking to it is better than waffling and giving in to self-doubt. If you decide to go in one direction with an area and then later decide to go in the opposite direction, the result is often mud and some middle-of-the-road value that contributes nothing. Spending more time thinking and less time painting will help you with this problem, because you can ponder the alternatives. If you think through the alternative consequences for each action for a while, you will be better able to stick with and follow through with your decisions.

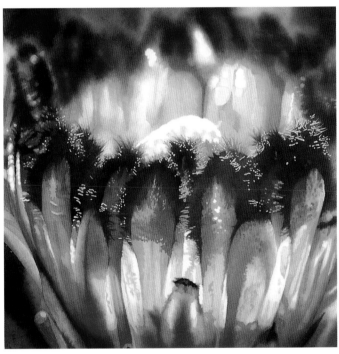

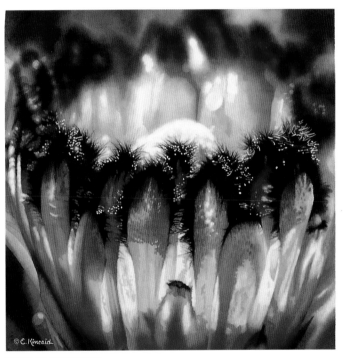

THE PROBLEM

In Protean Light, *I wanted to capture how the sunlight lit this flower from within. I chose a square format and cropped in closely to intensify the sensation of looking directly into a light source. Expressing light depends upon strong value contrast. Here, the image is pretty and the colors are in place, but the light doesn't glow. The painting needs stronger contrast.*

THE SOLUTION

The darks need to go all the way to black, and all the supporting colors need strengthening. I continued to glaze with Indian Yellow, Cadmium Red Orange, Quinacridone Burnt Scarlet, Permanent Rose, Winsor Red, Anthraquinoid Red, Quinacridone Violet and Winsor Violet. Once the dark areas were deep enough, I glazed the deep violet areas with Neutral Tint. At the very end, I lifted out lights and softened edges with the scrubber. The contrast is enough to give the illusion that the white paper is light.

Protean Light
13½" × 13½" (34cm × 34cm)

Add Strong Bias to Your Shadows

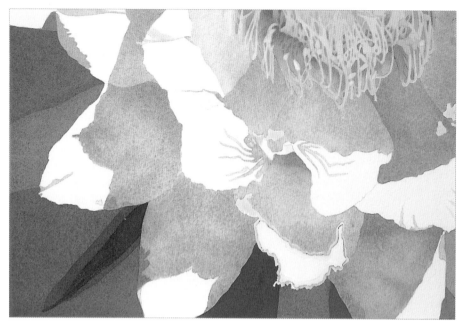

Shadows don't need to be dull. When a quiet color is definitely warm or cool, the painting is more alive. To fix this painting, color needs to be lifted from one area, and another area needs to be darkened. I need to make room for lively color contrast.

MATERIALS LIST

BRUSHES
1½-inch (38mm) flat
nos. 3, 6 and 10 rounds
scrubber brush
toothbrush

MASKING MATERIALS
drafting tape
Frisket Film
colorless liquid Frisket
tissue

PALETTE
Aureolin Yellow
Indanthrone Blue
Permanent Rose
Thalo Blue
Ultramarine Blue
Winsor Violet

IDENTIFY THE PROBLEM

1 I built the shadows of this cactus flower from glazes of Cadmium Red Orange and Ultramarine Blue, and the resulting gray is too balanced. Also, the shadow surrounding the flower center doesn't reflect the yellow glow from the center.

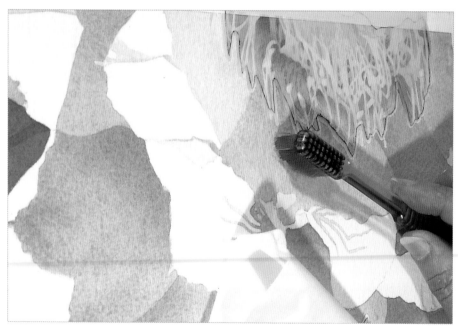

MAKE ROOM FOR IMPROVED COLOR

2 First protect the center section with masking film and masking fluid. With a no. 10 round, glaze the outer shadows with Permanent Rose and then Winsor Violet. Deepen the contrast of the background with a 1½-inch (38mm) flat and more glazes of Ultramarine Blue and Indanthrone Blue, so that the value range allows for deeper flower shadows. Scrub the central shadow with water and a toothbrush, blotting with tissue to lighten.

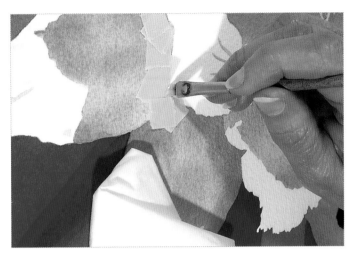

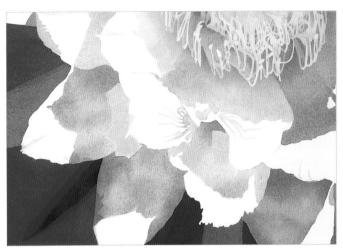

ADD GLAZES AND LIFT PAINT

3 Working wet-into-wet and using a no. 6 round, glaze the central shadow with Aureolin Yellow and then Thalo Blue. Glaze the outer region of the central shadow with Permanent Rose and a no. 6 round, let it dry and then glaze the area with Ultramarine Blue. Remove the masking fluid. Adjust the colors in the center using a no. 3 round. Clean up the rough edges left from all the glazes. Lay down pieces of drafting tape to protect any hard edges, then lift paint with the scrubber brush and water. Blot the area with a tissue.

ASSESS THE RESULTS

4 The white is now pure, and the crisp edge of the shadow is preserved by the tape.

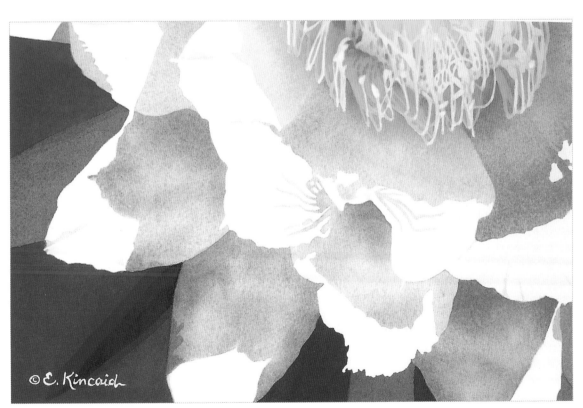

THE IMPROVED PAINTING

Cactus Piece is still a quiet painting, but the violet shadows enhance the warm center and the green central shadow reflects its neighbor.

Cactus Piece
7" × 10" (18cm × 25cm)

Calm the Jumpiness

Perhaps the problem is that the painting is too "jumpy." All of the elements are jumping off the page with equal intensity, irrespective of their relative importance to the whole. An example is a painting of a stone wall. The wall is the important thing here, but it is easy to get caught up in rendering the detail of the various stones, with all their forms, textures and colors. If this has happened, the solution is to float a glaze onto the entire wall, warming, cooling or graying it in the process. Since the last layer in any stack of glazes is always the dominant one, this glaze will pull the wall together and force it to act as a visual unit. Another example is a painting of a forest, where all the trees jump out and claim the viewer's attention even though you intended the forest to function as a "wall," a mere backdrop to the important action of your story. In this case, a glaze of blue across the whole forest will pull the trees together and push the whole thing back at the same time. The glaze gives every individual color in those trees the common ground of this one glaze, and it reduces the contrast between darks and lights by eliminating the lights. Scrubbing the forest to lighten it and then glazing with a blue-gray, will cause it to recede even further.

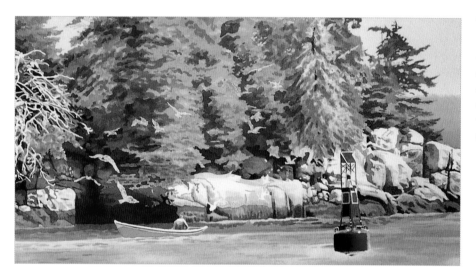

THE PROBLEM

The idea for this image is to capture the spray of seagulls and use them to move the eye through the scene. The critical decision point is when to remove the masking fluid from the seagulls. Here everything is in place, the fisherman and buoy stand out well, but the seagulls are lost against the too busy and too light-valued forest.

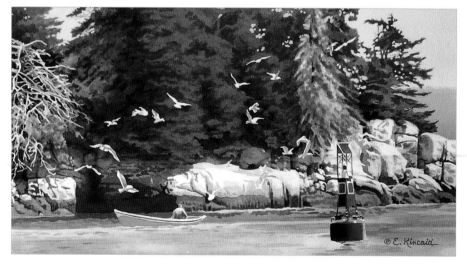

THE SOLUTION

I've glazed the forest with more Thalo Blue to deepen it and then Sap Green to warm it. I reduced the contrast and jumpiness of the dead tree on the left with glazes of Ultramarine Blue and Indanthrone Blue. Merge the standout tree above the buoy with the rest of the forest with Hooker's Green Deep, Sap Green and Brown Oxide. I deepened the blues and violet of the dark cove and then glazed the rocks where needed to increase contrast with the birds. I anchored the buoy by glazing the water with more Ultramarine Blue. Now the eye circles from the bright red buoy to the fisherman in his bright orange boat and up through the spray of seagulls and on around. Control contrast to make this happen.

Nova Scotia Morning
7½" × 14¼" (19cm × 36cm)

Sharpen the Focus

Sometimes a painting lacks focus and strength because everything in it gets equal attention. A great way to quiet some things down is to apply a large glaze with a wide brush. A large glaze can unify whole sections of a painting, throwing anything left out into high relief. For this solution, I most often use blue because it also cools and causes things to recede.

Sometimes a painting loses its focus by having an overall middle value, with very few darks and lights, either accidentally or as the result of waffling. I protect myself from this mishap by using several masking techniques, as detailed in chapter four. Lights are very important because they give a painting its sparkle; darks are essential because they can give a painting weight and substance. Both help focus the viewer's attention. Massing, or grouping,

darks and lights together is a powerful compositional tool. But if you have lost the darks and lights, all is not lost! Decide where the lights should be and lift paint. Decide where the darks should be and glaze. Often, areas end up too light because it's difficult to determine the ultimate dry value of pigment when it is still wet. The remedy is to keep glazing as many times as necessary, even until your darkest darks are close to black. Don't assume an area is finished just because it's covered with paint.

The worst mistake you can make in a painting that has value problems is to give up and declare the thing a failure. You can always lift paint, and you can always add paint. I tell my students, "Keep your solutions large and your actions light." This means to float the glazes on using the

largest possible brush and a light non-scrubbing action. When you need to lift color, do so gently and only increase force if a gentle touch didn't work. If you used a scrubber brush and it didn't lift off enough color, let the area dry and then try lifting again. Don't give up until the area is the value you need it to be. If you lift all the color, basically taking an area back to the original white paper, you might need to glaze it with a new color so the area will work in your painting. You can glaze on top of a scrubbed area, but only with a light touch and not too many times. Scrubbing lifts off sizing and some of the paper, leaving the area damaged. This means the scrubbed paper will now act like a blotter and the next washes you add will soak deeper into the paper.

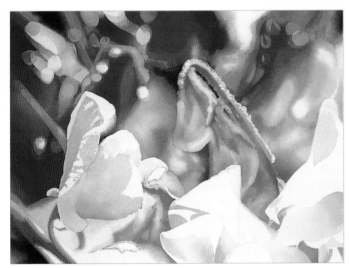

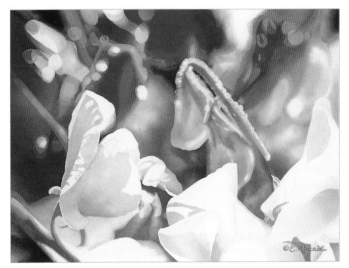

THE PROBLEM

The ethereal quality of this magnified bouquet of sweet peas captivated me. A lot of its appeal is in its abstract quality—the way that there is just a suggestion of forms and nothing is quite clear. At this stage, I love the dance of color and the wildness of the image, but my eye gets a bit lost moving through it. The challenge is to reduce the chaos without reducing the life of the painting.

THE SOLUTION

The answer is to focus attention more clearly on the central players—the shadowed white flower and yellow/red flowers that seem to face each other on center stage. Do this by increasing contrast. Glaze the light foreground flowers with Permanent Rose and Winsor Violet to bring them into focus. Deepen the background at the base of the centers of interest, too. With a focal point established, the eye can travel around but always has a home base. The painting is now grounded.

Sweet Pea Dream
10½" × 14½" (27cm × 37cm)

Fixing Mistakes in Form

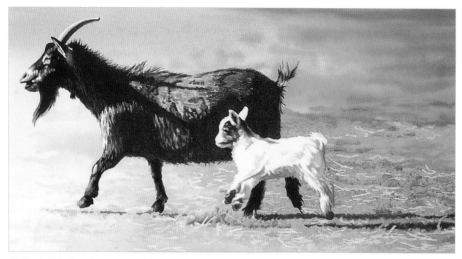

STUDY YOUR RESULTS

1 *Goats on the Run* is almost finished, but it needs a little tweaking to bring it to life. Most of this can be done by lifting paint with the scrubber brush. The mother goat's face needs some correcting, the baby goat needs some softening and the outer edges of the mother need softening to create a rounder feel. The hooves need to be better connected to their cast shadows.

Drawing problems are a frequent hurdle to successfully completing a painting. This problem was created in the initial drawing or by brushstrokes obliterating correctly drawn lines along the way. Sometimes a drawing will seem fine when it is just lines, and mistakes are revealed only when the lines become form. Masking fluid's tendency to spread out after application or the artist's failure to completely fill in shapes with the liquid mask can also cause problems: Fine lines can become fat, objects can grow unwanted lumps or chunks can be cut out of edges. First, determine the right shape, redrawing in pencil if necessary. This done, the solution is once again to add or subtract, probably on a very small scale. Use a small brush to paint patches of color to match the background next to any shape that needs to be shaved. Next, lift color where needed.

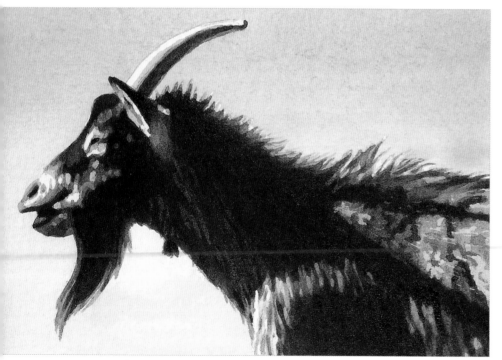

FOCUS ON AN AREA

2 A close-up shows the mother's face before the final adjustments. The top of her head has a lump that needs flattening, some blue needs to be lifted next to her eye, and some hairs need lightening.

MATERIALS LIST

BRUSHES
no. 1 round
¼-inch (6mm) flat scrubber
 (fabric painting stencil bristle brush)

MASKING MATERIALS
craft knife with no. 11 blade
drafting tape
self-sealing cutting mat
tissues

PALETTE
Indian Yellow
Winsor Violet

CUT SHAPES FROM
DRAFTING TAPE

3 Place pieces of drafting tape on a self-sealing cutting mat or a piece of glass or plastic. Using the craft knife, cut out the shapes that need to be lifted from the painting . This takes some trial and error to get the right size and shape. For really complex shapes, trace the shape with tracing paper and use that as a cutting guide.

LIFT PAINT

4 Place each drafting tape template onto the corresponding spot on the painting. Rub the tape templates down with your finger to make sure they adhere well to the paper. Wet and then scrub the area with your scrubber brush to lift and loosen the paint. Use a tissue to blot up the paint. Remove the tape immediately and blot any excess water. Let it dry thoroughly before applying any new paint to the area.

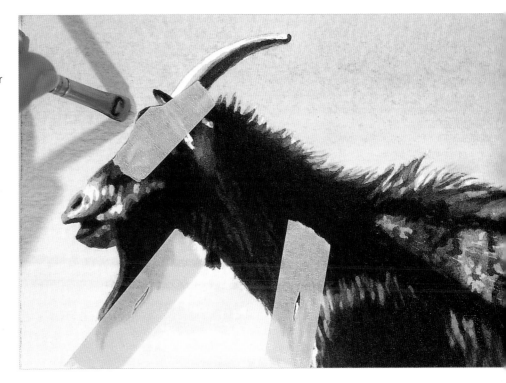

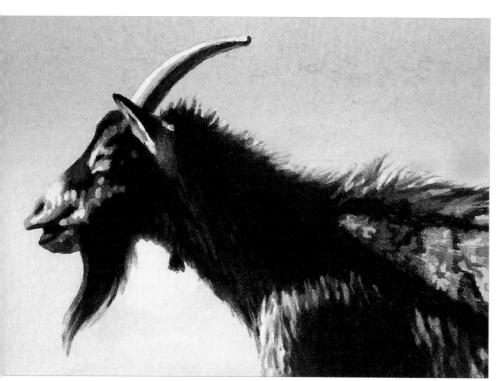

5 To complete this area, use a no. 1 round to paint a dot of Indian Yellow next to the mother's eye.

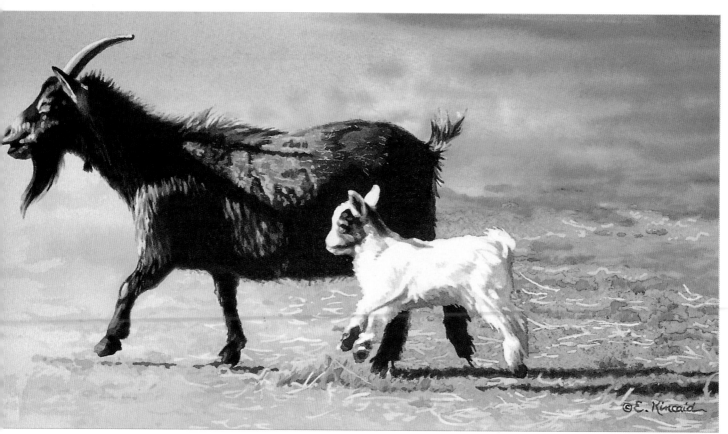

ADD THE FINISHING TOUCHES

6 To finish, soften the outer edges of the mother goat's body with the scrubber. Give the baby a few more touches of color and of softening, and enlarge the Winsor Violet cast shadows to envelop the hooves better.

Goats on the Run
7½" × 14⅜" (19cm × 37cm)

Fixing Lost Vision

Sometimes you get lost along the way in a painting, so the result doesn't match your original vision. This doesn't necessarily mean the result's bad. Perhaps it has just taken a new path and is something equally fine. It may even be better than your original idea.

As an analogy, consider the story of the woman who goes for a hike in the mountains and gets lost. Because the hiker loses her way, she meets the love of her life. You might say that it was a terrible experience to get lost, but look at what she found! You may be clinging to your original idea too much, so you are blind to the value of what you have. Try to see your painting with the fresh eyes of a stranger, someone who doesn't know what you planned when you began. The painting may still need some fine-tuning, but if you never recognize what you have, you are apt to trash it with heavy-handed "repairs." Your vision needs to be flexible.

A NEW VISION

The background for Big Rose *was a real voyage of discovery. I tried lots of things, and some things failed. Along the way, I found something new, and when I followed that new path, I created this painting.*

First I painted the orange marigolds in the dark background with flat glazes that left the flowers bright and hard edged. They were pretty, but they drew attention away from the rose. My solution was to wet down the whole area and paint a dark wash around the flowers, giving them soft edges. I then dropped intense Cadmium Red Orange into the flowers and then glazed Quinacridone Violet circles around the flowers to deepen their color.

Big Rose
21" × 13½" (53cm × 34cm)

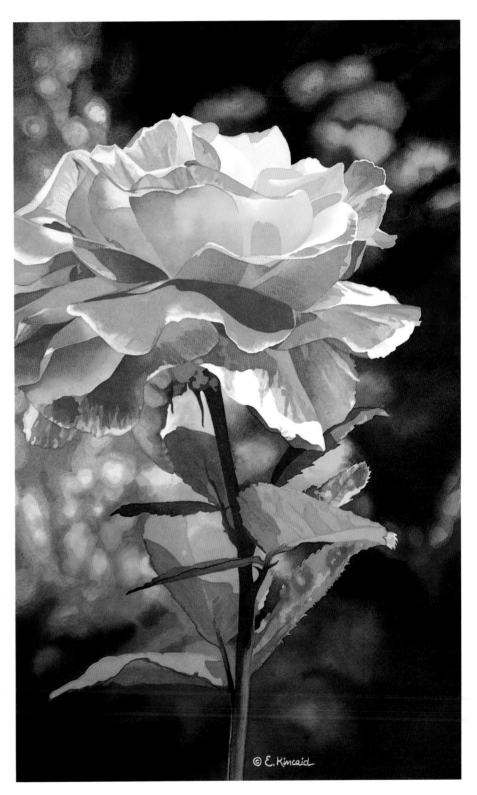

© E. Kincaid

Conclusion

My hope is that as you reach the end of this book you have a greater understanding of how to paint light in watercolor. I want you to be able to experience what I experience when I see the world and then be able to paint what you see. Painting light gives life to everything you do. Remember to look at the world for the first time, every day. Draw. Strong design is more than just a list of rules. The design of a painting is what reaches out and grabs the viewer. Design provides a path for the eye through the painting and a reward for spending the time there. Don't neglect this step in the development of your painting idea. Mask big areas with masking film to protect your paper and small areas with masking fluid. Masking is the tool that allows you to use those big brushes and to have the freedom that makes watercolor magical. Set up a place to work where you are free to concentrate on the painting. "Play" the painting as if you were playing an organ, with all your tools ready. Think long, but paint fast, and use the biggest brush you can. Water will make your paint dance, so make it work

for you. Be bold with color and play with your brush—let your brush dance with color across the paper. Color is more than theory. Color is the music that your painting dances to. Use color in a playful way. Make mistakes and then play with where that takes you.

The dance between light and shadow is the heart and soul of this book. The dance begins when you see light. Painting light is often more about painting shadows well—in watercolor, the light is often simply the white of the paper! Creating the illusion of light brings life to a painting and strength to the design of the painting. Texture is fun to play with in painting. Not all paintings need texture, but in the right place, texture makes your paintings richer. The last step in every painting is the most important: how to tell when the painting is finished. Don't rush. Take some time. Step back. Do you feel a rush of emotion when you look at what you've created? Does your heart swell? Then you are done. Painting is all about that feeling. You'll get there! Practice, practice and practice!

A HEART OF LIGHT

I want to draw you into the heart of this flower. There are many possible design choices to make with this iris, but this painting just tells the story at the center of everything. All the other information is unnecessary.

Deep Inside
21" × 13½" (53cm × 34cm)

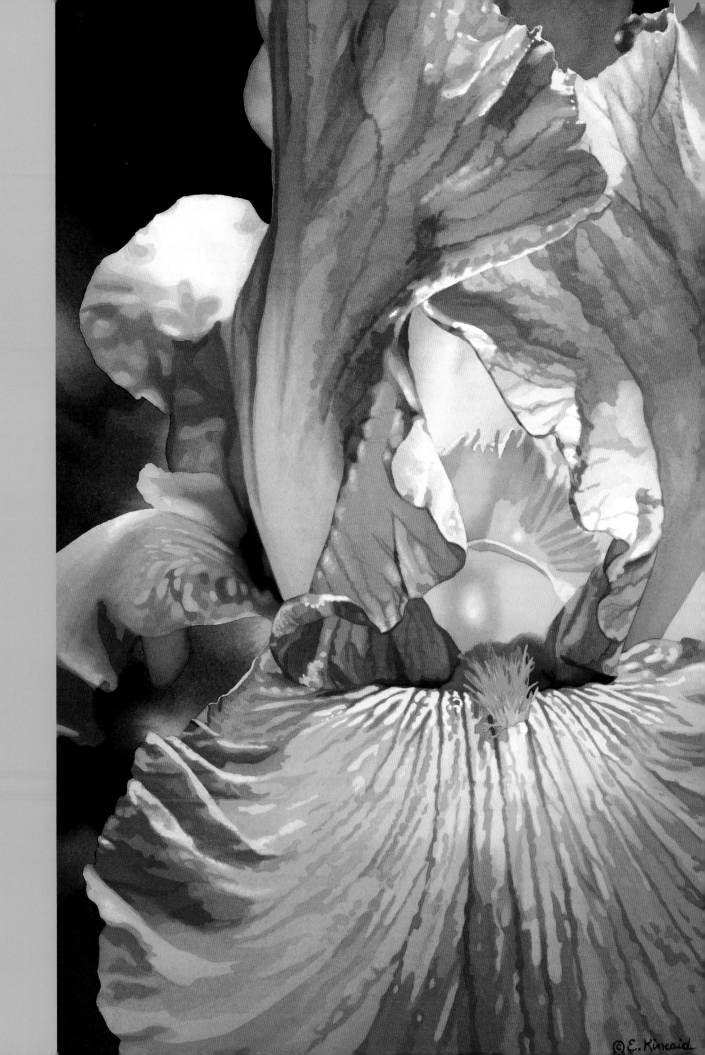

©E. Kincaid

Index

THE BEST IN WATERCOLOR INSTRUCTION AND INSPIRATION
is from North Light Books!

Here's all the instruction you need to create luminous paintings by layering with watercolor. Linda Stevens Moyer provides straightforward techniques, step-by-step mini-demos and must-have advice on color theory and the basics of painting light and texture—the individual parts that make up the "language of light."

Dory Kanter's inspirational guidance is perfect for both beginning and experienced artists alike. *Art Escapes* gives readers a fun, easy-to-execute plan for building an "art habit." Inside, you'll find daily projects for drawing, watercolor, mixed media, collage and more. With *Art Escapes*, you'll experience heightened artistic skill and creativity, and find the time to make a little bit of art everyday.

ISBN 1-58180-189-0, hardcover, 128 pages, #31961-K *ISBN 1-58180-307-9, pob w/concealed wire-o, 128 pages, #32243-K*

These books and other fine art titles from North Light Books are available at your local art & craft retailer, bookstore, online supplier or by calling 1-800-448-0915 in North America or 0870 2200220 in the UK.

Incredible Light & Texture in Watercolor uses clear instructions and illustrations to teach you simple techniques for portraying beautiful impressions of natural and artificial light as well as various atmospheric conditions. Step-by-step demonstrations will teach you how to use the interaction between light and texture to set the tone of a painting.

Take advantage of the transparent, fluid qualities of watercolor to create startling works of art that glow with color and light! Jan Fabian Wallace shows you how to master special pouring techniques that allow pigments to run free across the paper. There's no need to worry about losing control or making mistakes. Wallake empowers you to trust your instincts and create glazes rich in depth and luminosity.

ISBN 1-58180-439-3, hardcover, 128 pages, #32657-K

ISBN 1-58180-487-3, paperback, 128 pages, #32825-K